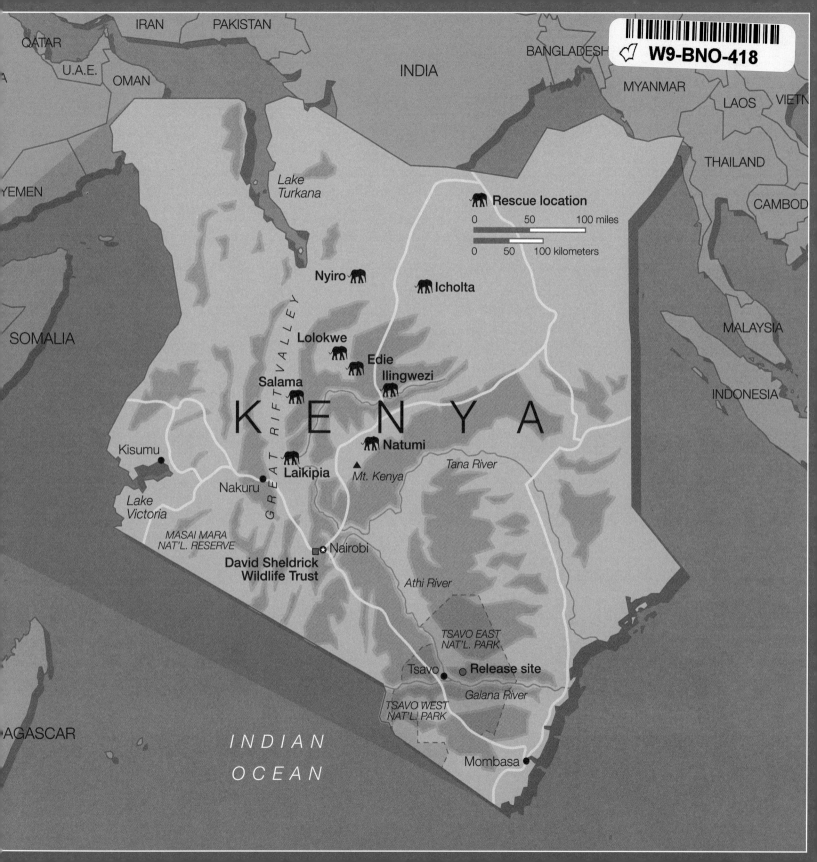

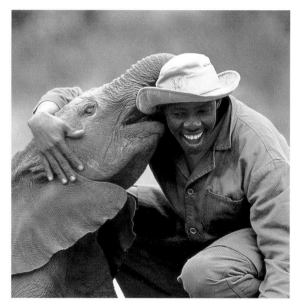

For Ellie ~
who loves ellies!
Happy Birthday!
~ Leah
2002

Wild

Orphans

Photographs and text by Gerry Ellis

welcome
BOOKS

new york ✶ san francisco

Acknowledgments

I AM INDEBTED to a number of people for their kindness, understanding, and trust over the past few years. It's that trust for which I am most grateful; without it the work you see here would not have been possible. All thanks begin with Daphne Sheldrick (please see my introduction), her daughter Jill Woodley, and head keeper Mishak Nzimbi, who let me have the freedom to push the envelope and create images no one had yet done; the experience has been one of the most rewarding of my life.

To my wife Karen, who inspired *Wild Orphans* with her ideas and words: The seed you planted germinated and grows here; I can't thank you enough. A special *asante sana* to Bunny Shaw, who has been my guiding light and angel in East Africa for more than a decade. Through your generosity, love, and a seat at your bar, I know an Africa past and present few will ever share.

To Jill, JF, and Angela: Thank you for the meals, beers, and all your behind-the-scenes hard work making the future of the DSWT bright.

And thanks go to the many others in Kenya and in the USA who have been extremely supportive of Wild Orphans: Parisa Haj-Ali-Akbari, Michael Durham, Stacy Fiorentinos, Joseph, Wambua Kikwatha, Trista Kobluskie, Patrick Matuku, John Malonza, James Mbuthia, Michael McGuire, Sarah Pagliasotti, Lissa Rueben, Simon Trevor, Tanya Trevor, Michael Wilhelm, Sammy, Richard and Margaret. I have unfathomable gratitude to Marcia Gordon and her staff at Park East Tours for their help and generosity in relieving me from the burden of making endless travel arrangements between home and Africa.

Additional thanks go to Gregory Wakabayashi and Natasha Tabori Fried at Welcome, without whose patience and understanding through endless e-mails and tight deadlines this book would not have come to life. And to Lena Tabori, my "malaika," thank you for your faith and caring.

Finally, I am indebted to a group of men whose work goes largely unseen by many but without whom there would be no Orphan 8 or any other orphans roaming wild—the keepers: Mishak, Benson, Menza, Jako, Edwin, Julius, Mutua, Patrick, Jackson, Permenas, Bernard, Isaac, Lucas, Benjamin, Richard, Josephat, Justus, Peter Musyoki Mbulu, Charles, Amos, Phillip, Morris, Jacob, Dismas, Vincent, Nicholas, Luka, Atanash, Joseph Musau Mulei, Mule, Pius, Peter Nyaga Ngari, David, Joseph Sauni Agostino, and Vincent.

While it may be my photos and words that you see here, it's the heart and soul of many who have made this book happen. I am not an expert on elephants, but I do feel as though I am much closer to understanding a fellow species with which we share the world than ever before—my thanks to all the orphans whose misfortune nevertheless made it possible for us to learn.

—G.E.

Published in 2002 by Welcome Books,
An imprint of Welcome Enterprises, Inc.
588 Broadway, Suite 303
New York, NY 10012
(212) 343-9430; Fax (212) 343-9434
email: info@welcomebooks.biz
www.welcomebooks.biz

Publisher: Lena Tabori
Project Director: Natasha Tabori Fried
Designer: Gregory Wakabayashi

Distributed to the trade in the U.S. and Canada by
Andrews McMeel Distribution Services
Order Department and Customer Service: (800) 223-2336
Orders Only Fax: (800) 943-9831

Library of Congress Cataloging-in-Publication Data

Ellis, Gerry.
 Wild orphans / photographs and text by Gerry Ellis.
 p. cm.
 ISBN 0-941807-58-4
 1. Elephants--Infancy--Kenya--Nairobi National Park--Pictorial works. 2. Orphaned animals--Kenya--Nairobi National Park--Pictorial works. 3. Wildlife rescue--Kenya--Nairobi National Park--Pictorial works. I. Title.

QL737.P98 E467 2001
599.67'4'.967625--dc21

 2001056779

Printed in Singapore

First Edition
10 9 8 7 6 5 4 3 2 1

Contents

Foreword
Dr. Daphne Sheldrick

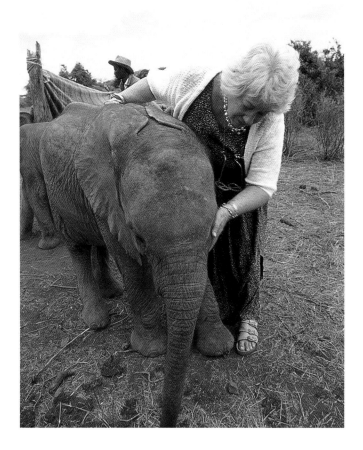

IT IS INDEED AN HONOR and a pleasure to be able to contribute this short foreword to Gerry Ellis's beautiful book featuring our orphaned elephants, for it portrays in such a sensitive way the wondrous elephant family that is so very dear to our hearts. Every image of every orphan brings back poignant memories, and symbolizes the dangers that stalk elephant life in today's troubled world—the loss of habitat through human expansion has forced these gentle giants into close proximity to humans, and that has generated conflict in which the elephants are always the losers. Then there is the suffering generated by human greed for their ivory tusks, which has torn the very fabric of their very human society to shreds, with countless orphans left in the care of young and inexperienced—although still compassionate and caring—young matriarchs who are little more than babies themselves. Today, unhappily, there are very few "natural" intact elephant families left in today's world. The elephants have lost the wisdom of their elders and this has had a profound effect on their lives.

These pages recall the same sort of tragedies that beset human society in many troubled places of the world. When a tiny calf is deprived of its family, it has lost that which is most important in a life that should span three score years and ten: the family. Suddenly orphaned, vulnerable and all alone, the calves arrive in our nursery severely traumatized, often wounded, and always overwhelmed with heartbreaking grief and despair. The joy of seeing them slowly come back to life compensates for the sorrow of losing many who never make it. But at least these die surrounded by love.

Raising elephants is not for the faint-hearted, for it is a long-term commitment charged with emotion and beset with pitfalls. Invariably, tears go hand in hand with

joy. Most rewarding is that moment that promises hope, when a baby elephant begins to play, something so touching that the human spirit is uplifted and suddenly the sound of laughter fills the air.

I have been working with elephants now for 50 years, in both a wild situation, when my husband was Warden of Tsavo East National Park, and since his death in 1977, hand-rearing their orphaned young. I have lived their trials and tribulations on an almost daily basis over the years, and have suffered along with them, but the elephants have taught me many important lessons of life. They demonstrate in a very human way the strong sense of family so important to our own society, and they share with us humans the same sense of death, revisiting the last resting place of a loved one to remember and reflect. They illustrate caring and compassion in a touchingly beautiful way, even from a very tender age, always conscious of the grieving of a newly orphaned newcomer, to whom they impart comfort and hope. They demonstrate forgiveness too, even after witnessing the death of their family at the hands of men, and they unceasingly impart a sense of wonder, endowed as they are with mysterious abilities we have yet to fully comprehend. Their sophisticated low-frequency language, hidden to human ears, carries messages to friends and loved ones far and wide; their "songs" at sundown, hauntingly beautiful, are perhaps lullabies or even prayers. Their ancient migration trails and inbuilt genetic knowledge about medicinal plants humble us humans. How elephants are able to surely navigate territory they have never before trodden, but which perhaps was known to their forebears, is a mystery to us.

Through the pages of this beautiful book, I hope that our orphaned elephants will be imparting a message to humans worldwide—the message that elephants are worthy of, and need, human compassion and understanding, that they must be handled with sensitivity and care rather than brutality; that they need the help of humans to halt the slaughter for their ivory tusks and allow them the space they need for a better quality of life on a small globe that they share with us.

Introduction
Gerry Ellis

FOUR YEARS AGO, eight baby elephants entered my life. Over time, they became mine. I called them the Orphan 8, and slowly they evolved as the focus of the Wild Orphans project. Wild Orphans was my attempt to put a face on the environmental issues I had been documenting as a nature photojournalist.

That elephants should become the subject of an entire book is the wisdom of my publisher, Lena Tabori. My original intention was to produce a single volume spanning several different animal orphanages I had been documenting, but Lena took one look at the elephant work and declared this alone was worth a book. Thus, the other orphans would wait their turn, and the Orphan 8 became my sole focus.

In the beginning, I had "hoped" to follow one— maybe two babies—at the orphanage for this project.

But before the first soupy trunkful of mud was flung onto my lens, there were three babies, then four, then five. . .the flood was under way.

In 1999, a severe and prolonged drought in north-central Kenya, combined with an increase in ivory poaching and incidents of "problem" animals, brought a deluge of babies to the David Sheldrick Wildlife Trust orphanage on the outskirts of Nairobi. The orphanage is unique in its ability to raise infant elephants and black rhinos to a state where they can return to the wild. That accomplishment is solely credited to founder Daphne Sheldrick.

I had worked in Africa for years, and elephants had always been a favorite photographic subject. But I had never imagined devoting myself solely to their story—which quite frankly I felt had already been done. The Orphan 8 proved me wrong.

At the turn of the 20th century, there were approximately 2 million elephants roaming the African continent. At the same time, there were approximately 1.6 billion people on Earth. Seventy years later, there were 1.3 million elephants, but more than twice as many people. The competition for space was intensifying.

The number of elephants dipped as the human population grew, and in the 1970s, the Ivory Wars began. Elephants had been hunted for centuries, their ivory poached to make everything from chopsticks to piano keys. Now, on battlefield after battlefield, elephants met a foe armed to kill with incredible efficiency and force.

By the mid-1980s, the African elephant was well on its way to extinction, and the world didn't seem to care. Even the conservation organizations seemed to take little notice. The poaching continued unabated, with the vast majority of ivory ending up in China, Japan, and the United States. Within a decade,

approximately just 300,000 of Africa's elephants were left, surviving in fragmented herds, principally in eastern and southern Africa.

Then, in 1990, on the heels of the most intense publicity campaign ever waged on behalf of an animal, the world placed a moratorium on the ivory trade. The naysayers—principally from the southern African states and Asia—said the ban would not protect the elephants, and the anti-ivory states said it was the only hope. As the market for ivory evaporated and the price plummeted, the latter were proved right. At last, across East Africa and a handful of other countries, elephant calves were being born with a chance at survival.

But the Africa these elephants are growing up in is far different from the one their relatives roamed. Poaching still exists (I have heard more often than I care to recall the sound of semiautomatic weapons), and as more and more land turns to desert, humans and elephants are forced to live together in more concentrated areas. What an elephant of the 21st century faces is a maze of fences and roads, modern barriers to ancient memories. Elephants don't understand our selfishness of space. When they encounter a fence, especially if it bars them from water or food, they destroy it. One fence too many, and we destroy them—deeming them "problem animals."

So I decided to take a journey, to follow an orphaned baby elephant from rescue to rearing, and finally to release. It led me further than I ever imagined, beyond places and people, over a bridge between species.

This journey would never have been possible without Daphne Sheldrick. Her courage, patience, and willingness to understand elephants with her heart as well as her mind has allowed her to boldly follow her own path. She has done this with great conviction for over 50 years. She is a tireless advocate and defender of elephants and all creatures. I am eternally indebted to Daphne, and thank her for having the patience and trust to allow me to follow the lives of orphans as no one has illustrated before.

This book is the beginning, rather than the culmination, of the Wild Orphans project. I realize the Orphan 8 are just the tip of the iceberg. What we do not see, or avoid seeing because we don't want to face the heartache, are wild orphans around the world, growing in alarming numbers. Something is wrong. The way we are interacting with life around us is askew. Healing needs to begin now.

The philosophy that the organization *Wild Orphans* has given birth to—GLOBIO—is that global biodiversity is synonymous with the awe, magic, and wonder of life around us. Over these 136 pages I hope to bring that idea to life.

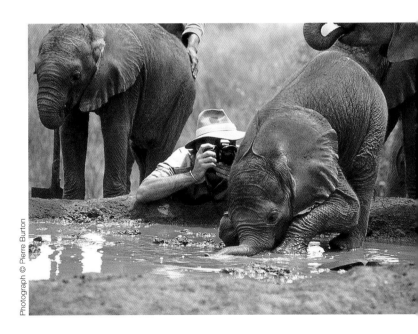

Photograph © Pierre Burton

1

Poachers, Pits, and Problem Animals
The Rescues

IN THE SUMMER OF 1997, no rain fell in the north-central bush of Kenya. This is traditionally a land of little rain, and the wildlife—especially the African elephant—is well adapted to fend for itself through a season of drying waterholes and shrinking rivers. As the waters evaporate under the scorching equatorial sun, the elephants either migrate into hillier country, where vegetation continues to grow green and lush, or use their magnificently skillful trunks to scrape ditches into the drying river beds where they find cool rivers of water that continue to flow beneath. So, as the clouds gathered and then drifted by without a drop, elephants simply adjusted to the conditions and lumbered on with their lives.

A year later, the cumulus clouds swelled, but still shared not a drop, and the lack of rain began to look like a drought. Grasses withered and rattled in the hot wind. Only the deeply rooted trees along ancient riverine systems looked alive, but even they were less than lush—like watercolors of their former selves in shades of dusty jade and powdery sage. Wildlife of every shape and dimension began to concentrate around waterholes kept accessible by the hard work of elephants. But rather than exude life, waterholes reeked of death, as lions repeatedly ambushed thirst-weakened antelopes, along with young and old of every species.

By 1999, the countryside was parched and its rain-starved landscape was showing deep drought scars. And by June, when it was clear that rains were another year away, even the infinitely resourceful pachyderms—on whom so many other creatures depended—were turning desperate. It was late June when the "orphan flood" started at the David Sheldrick Wildlife Trust orphanage in Nairobi. What began as a trickle of little lives turned into a deluge. By July, the gentle atmosphere of the orphanage was buzzing with activity from dawn to dusk. Following a new arrival, there was no peace and quiet between dusk and dawn, either. The onslaught of babies started a keeper-vigil that taxed the system and everyone involved. Meanwhile, in the north, well holes made by both humans and animals in the river bottoms grew deeper and more problematic for the elephants trying to find what scant water remained.

Simultaneous with the drought was a slow, deadly increase in ivory poaching. Rumors were beginning to grow about the possible repeal or loosening of restrictions on the international ivory trade at next year's CITES (Convention on International Trade in Endangered Species of Wild

Fauna and Flora) to be held in Nairobi, Kenya. The CITES body meets every two years to set parameters on the trading of threatened and endangered plants and animals around the world. The great irony is that while this is the principal body designated to protect species, and its decisions carry international weight, its ultimate objective, by its very name, is trade—not conservation. So, with the opportunity for ivory to once again have a global market, and with a drought forcing elephants to congregate at fewer and fewer waterholes, the gauntlet of survival was growing ever more constricting.

During that time, I hired a bush plane to survey drought conditions. En route, my pilot detoured to show me the ivory-poached carcasses of five adult elephants. Less than ten minutes later, we flew over tourists inside a national reserve innocently snapping photos of a group the same size. I have wrestled with those two images uncomfortably juxtaposed in my mind ever since. Most tourists I spoke with were comfortable in the belief that elephants were safe from poaching by law. That same month I met a one-month-old orphan elie named Yatta who had just lost her mother to a poacher. The ivory wars had subsided, but the battles were still flaring up—fueled by greed and indifference. (CITES voted in April 2000 to allow limited trade in elephant parts among some member countries from southern Africa.)

Humans were playing other roles in the elephants' demise, as well. As the impact of the drought sharpened, local tribesmen helped dig deeper river-bottom wells in search of water for their cattle. Holes I visited in October were 6 to 10 feet (1.9 to 2 meters) deep. At that depth, they became near-certain death traps for baby elephants. African elephants have the longest gestation period—up to 25 months—of any mammal, so the babies being born had been conceived before the drought began, but they were paying a very high price for entering the world now. Mother elephants desperate to reach water were using their long trunks to access the deepest holes, often lowering to their knees on a well's rim to extend their reach. Kneeling alongside their mothers in the hot, loose sand, little elephants teetered on the edge of disaster—and all too often disaster struck.

I never witnessed a baby falling into one of those wells, but I can imagine the nightmare. A baby elephant's scream is one of nature's most haunting voices—and the melee that ensues must

be equally frightening. One only has to spend a few intimate days with a matriarchal herd of elephants, or watch them visit the bones of a deceased member from years past to understand the intimacy of relations and their respect for life. A life-or-death struggle in the darkened depths of a well's muddy bottom traumatizes not only the infant victim, but also the entire herd.

We have no idea how many babies fall into ditches and holes and are rescued by their herds. What we do know is that in the extended drought of 1999, many were not. In a period of just a few months, five of what would eventually be called the Orphan 8 were discovered swallowed up by these watery traps and forever separated from their families. Ilingwezi, Edie, Icholta, Lolokwe, and, later, Kinna were the lucky ones, discovered before death closed in. Lolokwe still bears the scar of fending off a hyena before his rescue—the end of his trunk was nipped off, leaving him without his finger-like trunk tip. Kinna, abandoned to the elements, lost a defining section of her left ear to severe sunburn. I was told of one rescue in which rescuers first coming upon the scene couldn't understand why the baby hadn't sunk deeper into the soupy mud. But once in the well it was clear: It had been saved by standing atop the drowned body of another baby.

In times of drought, the fragmentation of viable countryside in which to forage becomes a serious issue. Sadly, *Shifta*—semiautomatic-wielding poachers with little regard for life of any description—have ravaged much of the dry country of Kenya, sweeping north toward the Somali border. Their toll on elephants over the past quarter century has been particularly severe. As a consequence, the remaining elephants have concentrated within the reasonably protective boundaries of reserves and parks. South toward more fertile country, farms and ranches now subdivide the landscape into a network of wheat, maize, and vegetable farms impossible for anything larger than a house cat to negotiate. The elephants that try to rely on the security of ancient corridors to greener pastures now find themselves under constant attack by farmers trying to safeguard a year's worth of work. These "problem animals" receive little sympathy from anyone. Thoma's rescue and struggle, told in the photographs over the next several pages, is the heartbreaking saga of one little problem animal.

In all, more than a dozen babies arrived for care and protection on the David Sheldrick Wildlife Trust doorstep during 1999—more than had appeared in the previous decade.

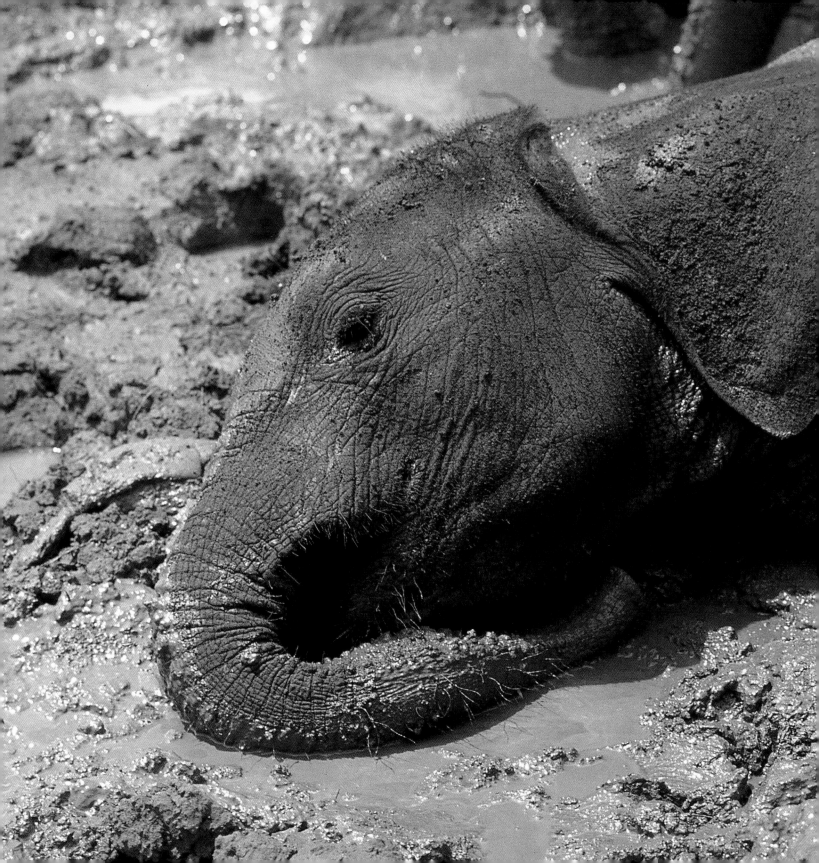

DURING A DROUGHT—which can last two or more years—traditional waterholes evaporate and elephants are forced to dig deep wells in sandy riverbeds to access water. But the very wells that insure the lives of the adult elephants often take the lives of their young. Newborn and baby elephants less than a year old can easily fall into deep wells during severe droughts. Once a baby is trapped in a well deeper than a few feet, there is little a panicked mother can do. Fate takes charge of the little life at this stage. If he's lucky, tribesmen coming to the waterhole with their cattle will notify help. If he is very lucky, help will arrive before he drowns, starves, or succumbs to dehydration. And if he's luckier still, he might make it to the David Sheldrick Wildlife Trust orphanage. Even with all that luck, a successful rescue is just the beginning of an orphaned baby elephant's fight for survival.

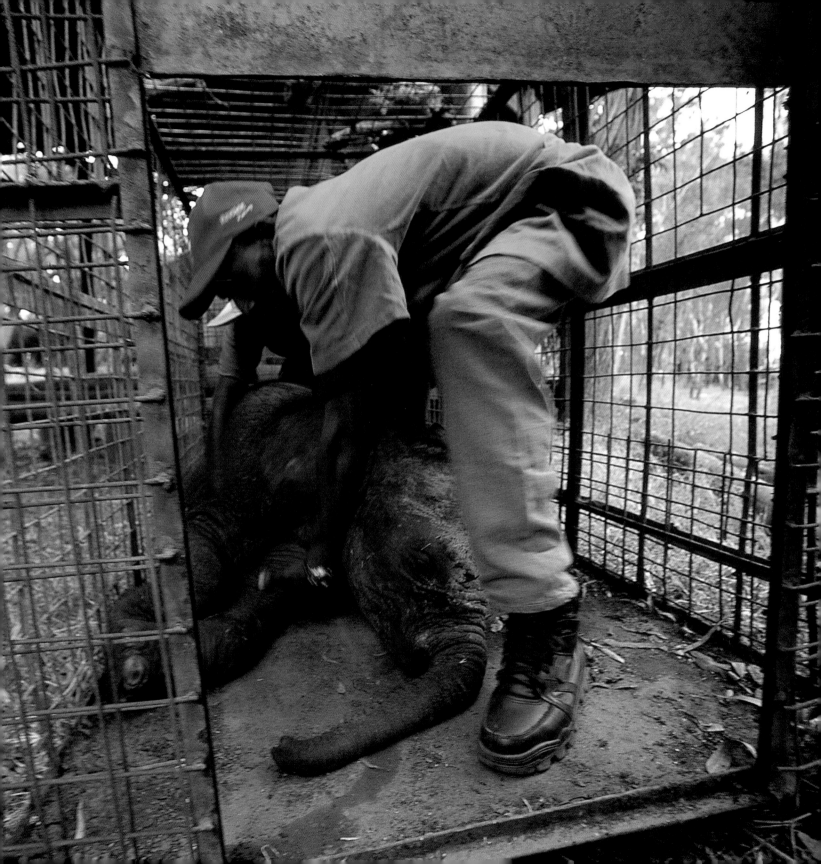

EACH RESCUE is a collection of circumstances that test the wills of a tiny orphan and his rescuers. No two rescues are exactly the same, and what a rescuer faces on arrival can be shocking—but there's little time to be spent on being shocked. Thoma's rescue, shown here, is late in the day, one day after farmers found her. Elephants in the region have developed night feeding patterns to avoid humans, and it is during such a foraging raid that her mother's herd is discovered and chased away. In the ensuing chaos, Thoma is tangled in fence wire and left behind. Police are notified the next morning and capture her. She is held overnight at the police station and the next day transported several hours to Aberdare National Park headquarters. When I arrive with Edwin and Permenas, from the Trust rescue staff, we discover a comatose baby a couple months old lying limply in the bottom of a cage used for lion capture and transport. Edwin and Permenas climb into the cage and lift the dead weight of the baby through the cage's tiny opening. Park rangers assist in hoisting Thoma into a truck for transport to the airstrip. We can only guess her seemingly lifeless state is partially due to shock. Imagine being imprisoned in a cage rife with the scent of the only major predator you know.

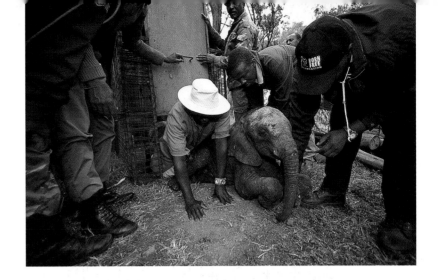

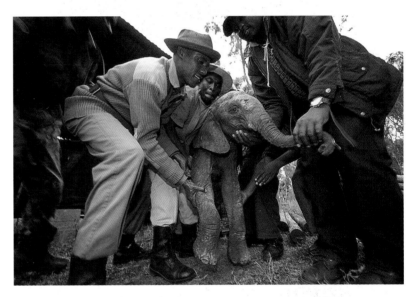

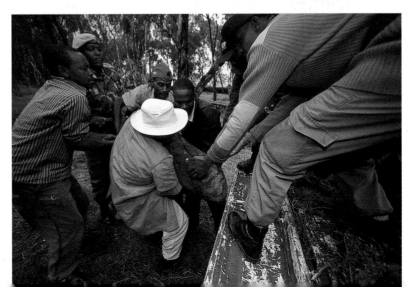

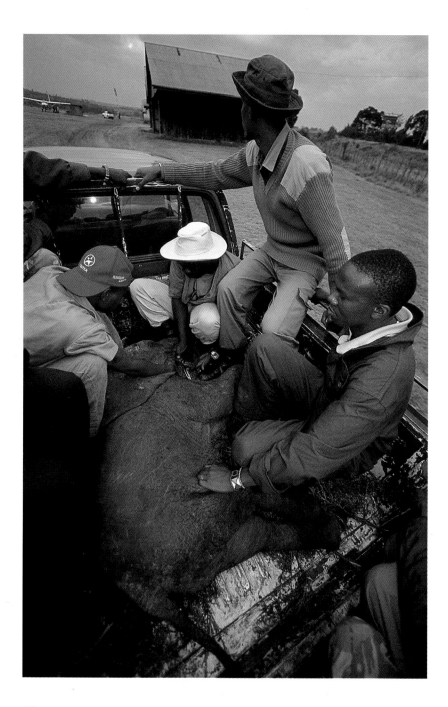

THE FIVE MINUTES to the airstrip seems an eternity. Everyone keeps close watch on Thoma's breathing **(left)**. There is serious concern the little elie will not live long enough to make it to the waiting plane. Generally, these rides are made after the accompanying Kenya Wildlife Service veterinarian has tranquilized the baby. In Thoma's case, there is no need for sedatives; in fact, we are all praying for a drug that will do the opposite.

Thoma is unloaded onto the grass strip near the plane and lead rescuer Edwin decides to try to force fluids down her before moving on **(right)**. A few minutes seem to stretch on forever as first one, then two bottles of milky liquid are shaken into Thoma's mouth. Her throat is stroked to encourage swallowing. Still she lies motionless.

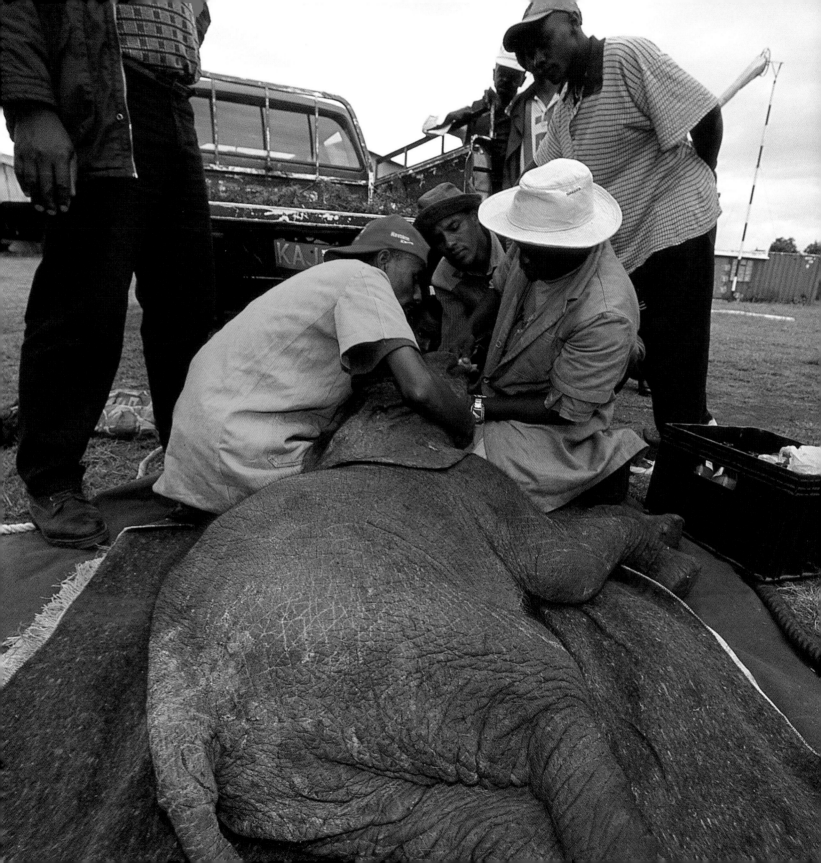

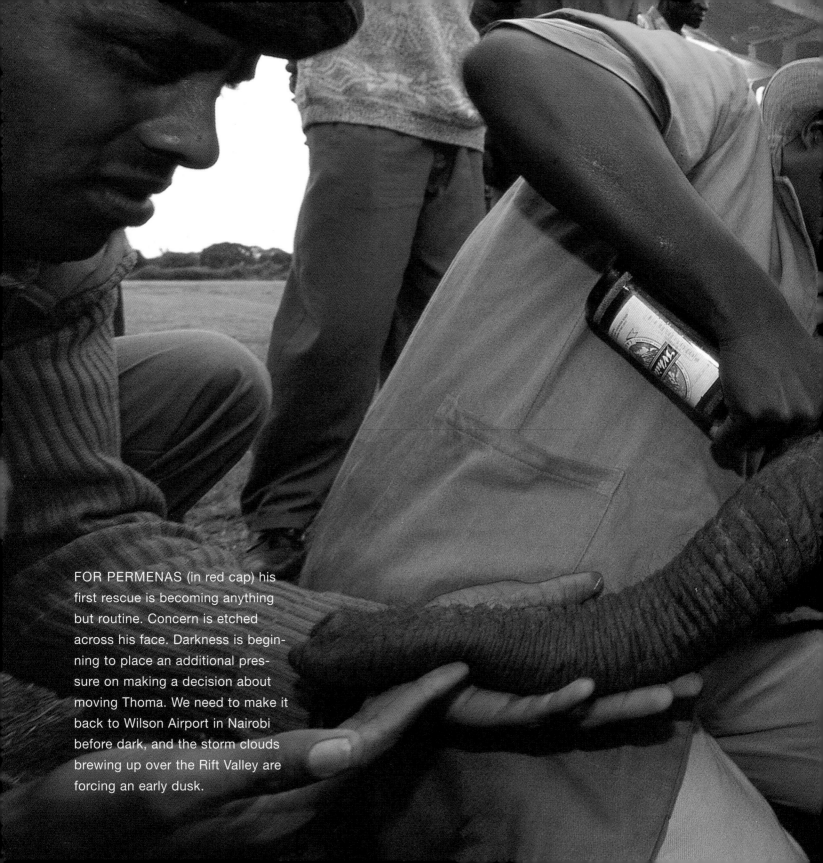

FOR PERMENAS (in red cap) his first rescue is becoming anything but routine. Concern is etched across his face. Darkness is beginning to place an additional pressure on making a decision about moving Thoma. We need to make it back to Wilson Airport in Nairobi before dark, and the storm clouds brewing up over the Rift Valley are forcing an early dusk.

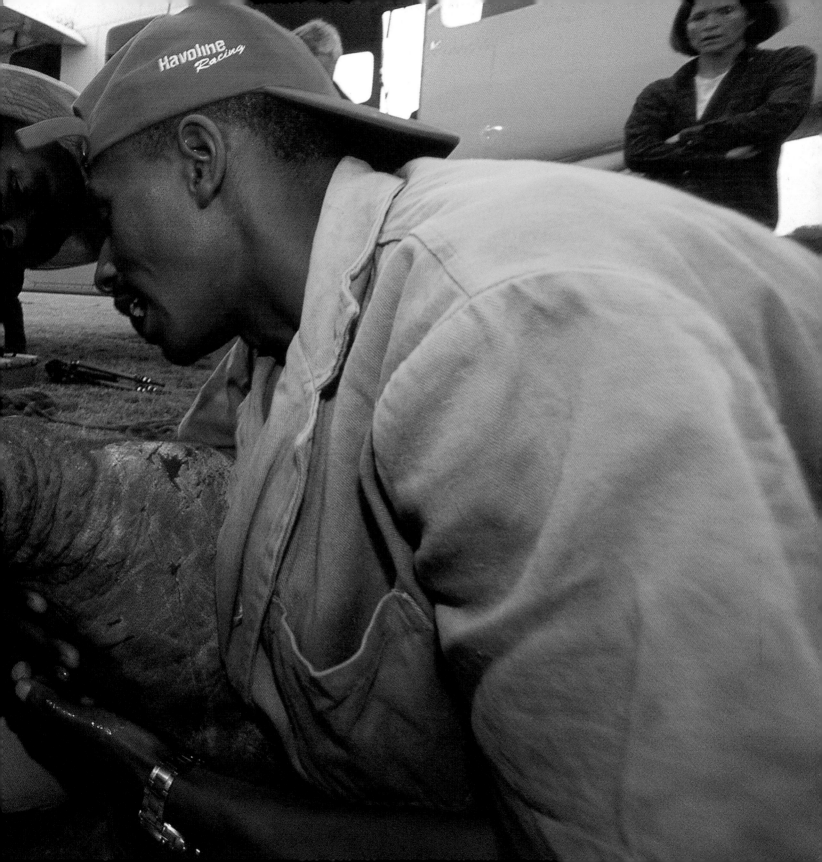

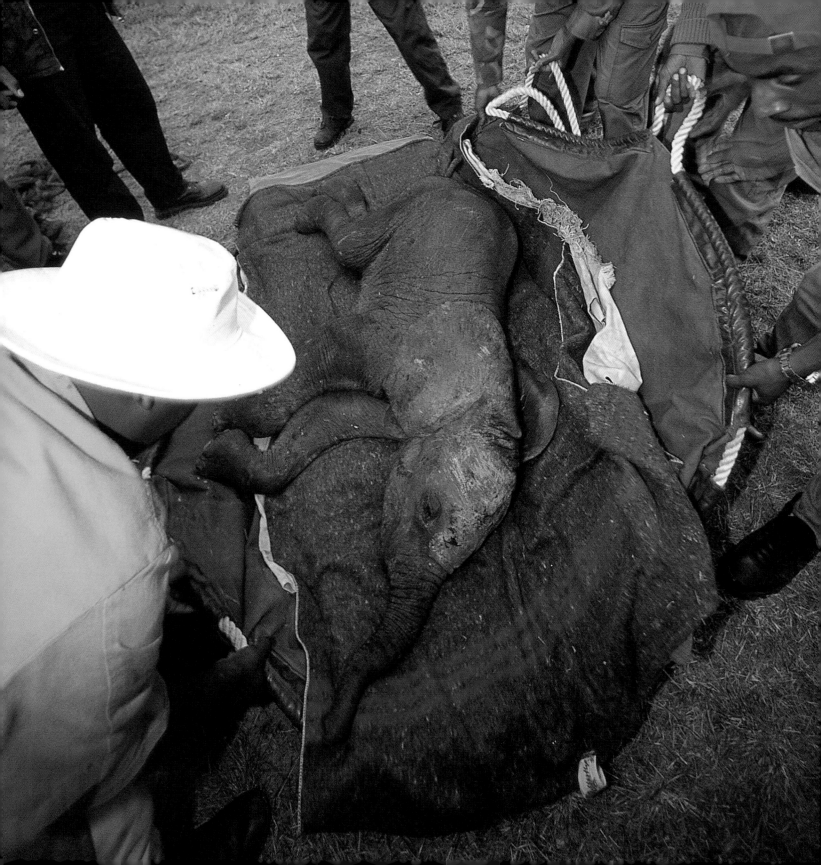

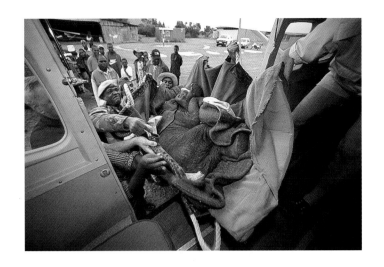

TIME HAS RUN OUT. We need to load Thoma and continue to try and revive her once airborne. Few tools are brought on a rescue: a crate of milk bottles; a mattress on which to lay the baby; the veterinarian and his kit; and a well-crafted stretcher (the size of the orphan is always a mystery until the rescue team arrives, as people are notoriously poor at guessing a baby elephant's age and weight). Moving and loading a tranquilized—or in Thoma's case, comatose—baby safely can take several strong arms and backs. The baby can be easily injured at this stage and the stretcher insures she is moved with care and unity. With its rear seats removed, an East African Air Charter's Cessna 210 becomes a perfect rescue plane for baby elephants a few days to a few months old.

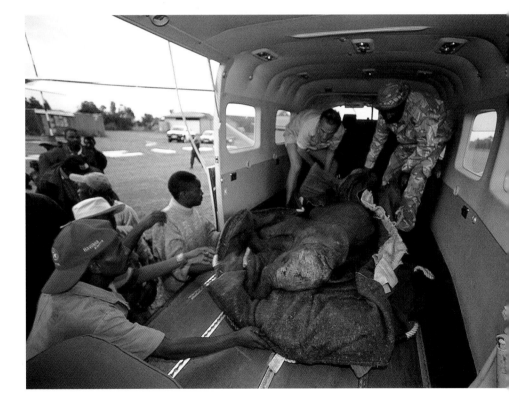

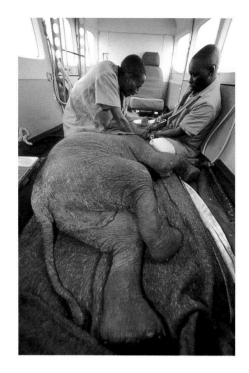

SECONDS AFTER we are safely airborne, Edwin and Permenas once again go to work trying to coax a glimmer of life back into tiny Thoma. This is my second rescue, and all attention is focused on the baby. I once look up from the camera at Edwin and recall him glancing at me, his eyes opening wide as if to say, "I just don't know." I think we are all preparing ourselves for the fact that we might land in Nairobi with a dead baby. Our rescue may turn into a funeral flight.

Rescuing baby elephants is far from a science. In all her years of saving orphan elephants, Daphne Sheldrick has raised 30, an amazing accomplishment; that figure, however, also represents nearly all that anyone has raised. Each rescue is a learning experience.

Five minutes before we land, we get the sound we are waiting for—Thoma erupts with an enormous trumpeting roar! The liquids and rehydration salts have worked. Permenas and Edwin both look up with giant smiles of relief. Mike Seton, our pilot, hollers back, telling us to make certain she stays down. Thoma is clearly alive, but not ready to get up and go anywhere.

Edwin leans back against the side of the plane, reaches down and cups his fingers around the tip of Thoma's trunk—even as he catches his breath he is making certain she is taking hers.

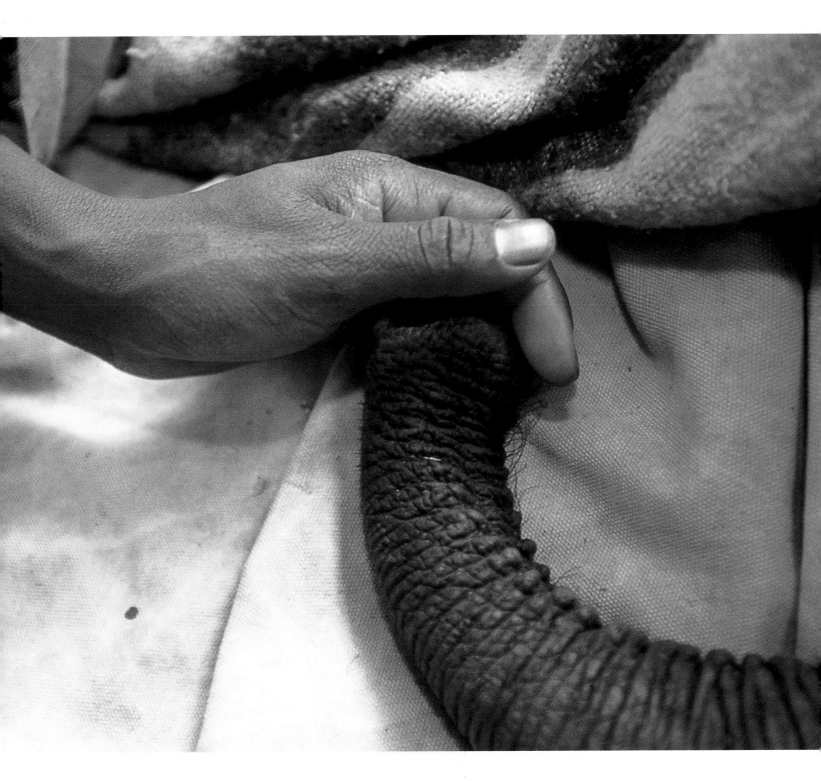

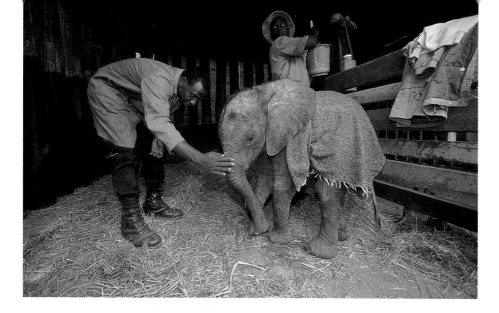

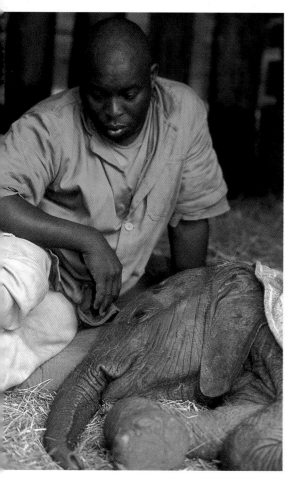

DURING HER FIRST DAY at the orphanage, Thoma's condition continues to improve, but the keepers are just beginning to see the extent of the puncture wounds she has suffered from the fence wire over the past couple of days. The keepers look as weary as little Thoma. Both Julius **(above)** and Edwin stay up all night with Thoma, who is inconsolable—restlessly pacing about her stable, frightened by the other orphan elies and her keepers. This goes on for an entire week before anyone gets a night of rest.

The first days are often the most critical. As Daphne explains it, "broken hearts" are one of the biggest wounds to heal. It's difficult to imagine the trauma felt by a baby elie in the days and weeks following the loss of its mother and family. It's during this crucial period that the patience and gentle spirit of the keepers save a life. Hour after hour, they accompany the baby through her every activity, never straying from her side. Barely able to stay awake himself, Edwin watches over a sleeping Thoma **(left).** The morning this photo is taken, he is well into 30 hours without more than a couple hours of sleep.

After a week of near isolation from the other orphans, Thoma begins to eat and sleep, and starts regaining her strength. With her newfound energy, she begins exploring her new world under Edwin's watchful eye.

More than once I have looked upon elephants as two creatures symbiotically sharing a life—the trunk and the rest of the animal. Here **(opposite)** the trunk explores a world beyond the stable and finds it good.

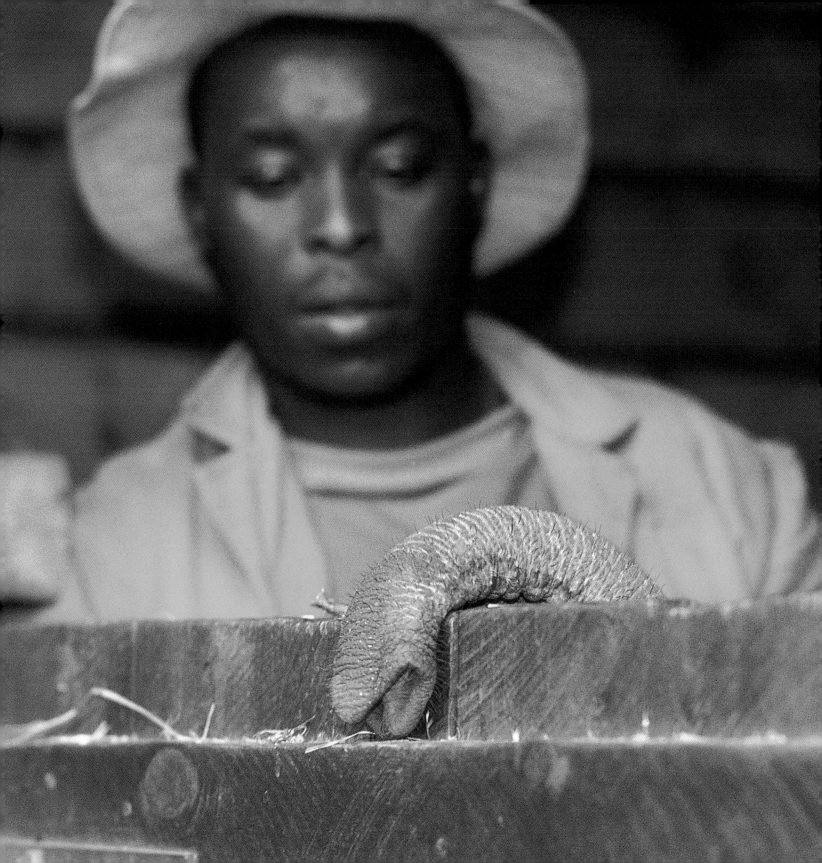

The "Orphan 8"
Baby Pictures

PEOPLE WOULD OFTEN ASK ME, "How do you tell the Orphan 8 apart?" The truth is at first I couldn't, unless one was obviously larger, like Natumi, or smaller, like Nyiro, or unless one had some scarred reminder of its orphaning, like Kinna's burnt ears or Lolokwe's "pruned" trunk tip. Some I struggled to tell apart nearly every day until their personalities emerged. Over time you notice the little things: temper, an extra roundness of the face, high cheekbones, a slight sway in the back, a rounder rump—even the timbre of their trumpet. These are the things keepers Mishak Nzimbi, Edwin, Julius Latoya, and the others taught me to see. Of course, if you spend every hour of every day for years with baby elies, as they do, the elies will become as familiar to you as your own child, sister, neighbor, or roommate.

The keepers used to astound me with their keen familiarity. I once had Mishak, Menza, and Bernard discussing a photo of some babies I had taken months earlier. After quickly identifying the obvious babies, they began a long discussion about to whom a single partial leg on the edge of the photo belonged. Eventually they agreed it was Edie because of her skin texture!

In the beginning, there is a tendency to see and treat the babies as miniature elephants. They are, after all, pint-sized replicas, but time taught me that looks are deceiving. Elies are as much miniature elephants as children are miniature humans—in some manners yes, and in others definitely not! Elies, like children, require love, discipline, guidance, and above all, infinite patience. They need to be treated like the babies they are.

The Orphan 8 experienced rescues similiar to Thoma's before I picked up their story at the orphanage. This chapter is their "baby book." Here you will be introduced to each one and told a bit about the circumstances surrounding his or her coming to be orphaned. The dates of birth are approximate, but for all of these little guys, life began anew on the days they were rescued.

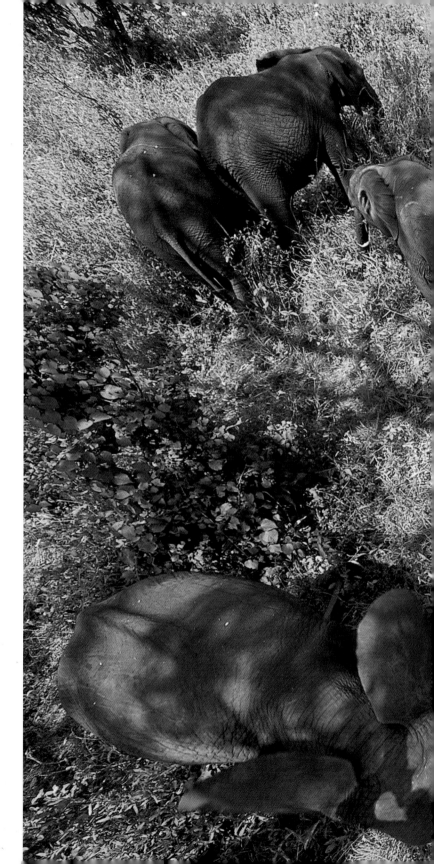

THE ORPHAN 8 and their keepers, accompanied by new orphans, seek refuge in the shadow of a large acacia tree. Equatorial heat in the Kenyan bush can soar above 90°F (30°C). Despite having the appearance of toughness, baby elephant skin is surprisingly delicate, especially around the face and ears, and refuge from the midday sun is important to prevent sunburn or sunstroke. For the Orphan 8, these quiet times also strengthen critical herd bonds. As a widely scattered collection of orphans, each comes from a separate location. The orphans' short-term health and survival depends on establishing new ties and confidence in both their keepers and their fellow orphans. At the time this photo was taken, there were over two dozen orphan elephants under the care of the David Sheldrick Wildlife Trust.

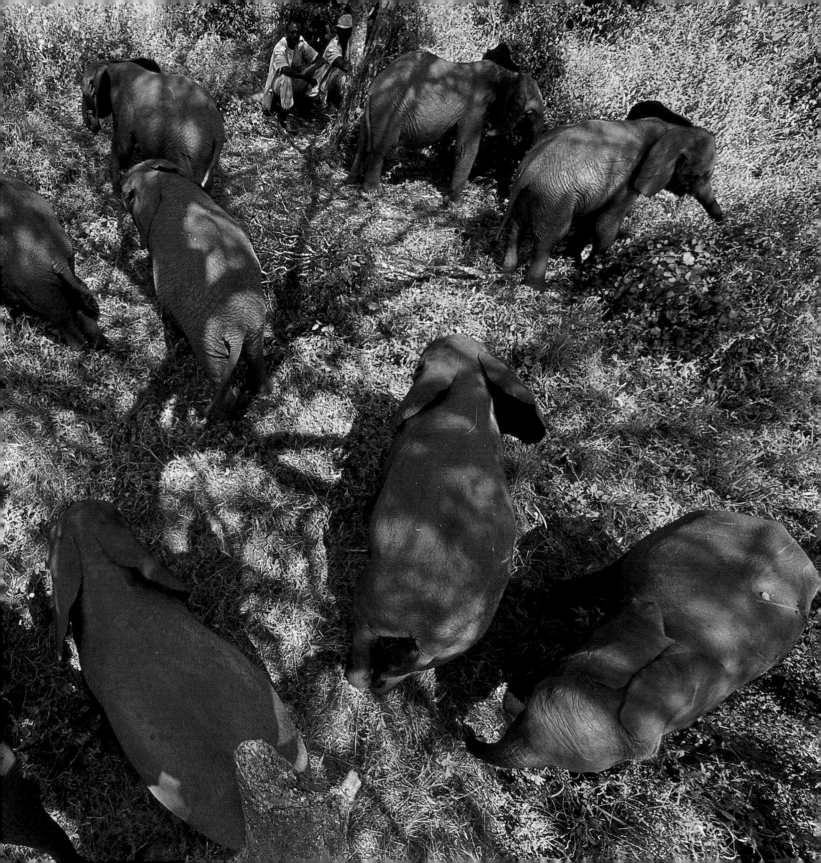

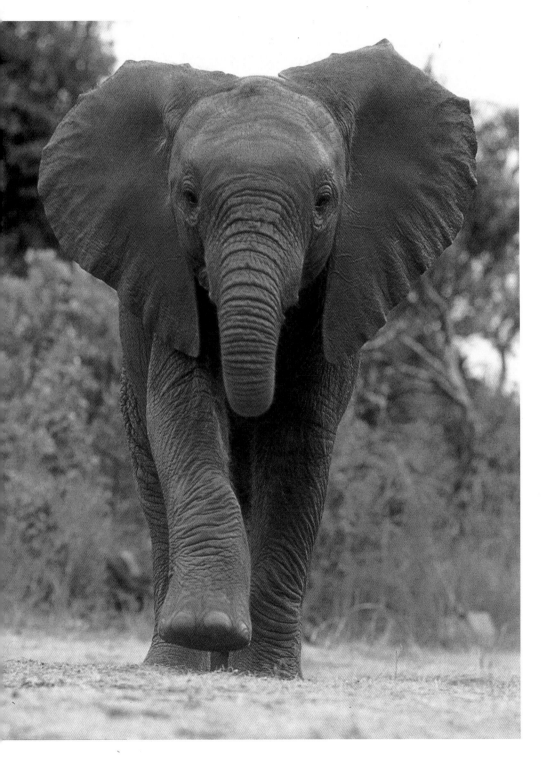

NATUMI

Born: February 1999
Rescued: April 1999
Orphaned after falling down a
well on the Eland Hollow Farm in
the north-central part of Kenya.

NATUMI'S MATRIARCHAL HERD
went to drink at Eland Hollows
Farm, which used to be a part of Ol
Pejeta Ranch in Nanyuki, not far
from the slopes of Mount Kenya. In
an attempt to scare them off,
Government Animal Control person-
nel opened fire on the herd. Three
elephants died as a result, including
Natumi's mother, and in the ensuing
chaos Natumi fell down a well. she
was just two months when she
arrived at the Nairobi orphanage.
Natumi looks upon herself as the lit-
tle matriarch of the baby group
called the Orphan 8. She is a lovely
little elie with great character and
self-confidence that sometimes gets
the better of her. She is possessive
of all those younger than herself
whenever she is the oldest in the
group, but with older elephants she
has become comfortable being just
one of the babies.

ICHOLTA

Born: August 1999
Rescued: October 1999
Abandoned by her herd after being trapped in the mud at Marsabit Mountain in the far Northern Frontier district of Kenya.

THIS TINY FEMALE was rescued from the mud of a drying waterhole at a place called Icholta, after becoming trapped and being abandoned by her herd. She was very small for her age, with soft fuzz on her head, but had good coordination. Icholta was estimated to be around six weeks old when she arrived in Nairobi. She is a very gentle, sweet, and friendly little elephant with a beautiful face. She is a great favorite with all the other elies and her keepers.

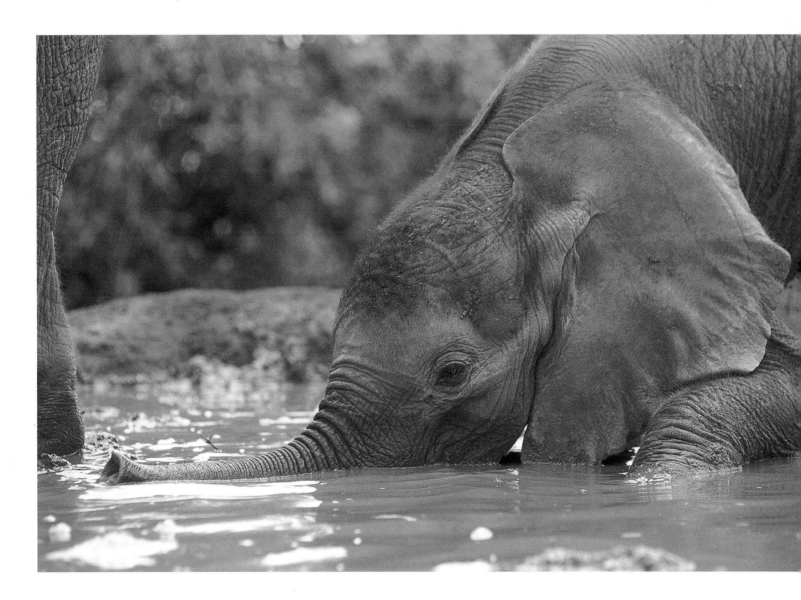

ILINGWESI

Born: April 1999
Rescued: April 1999
**Orphaned after falling down a
well in the north-central of Kenya.**

THIS LITTLE FEMALE comes from the Il Ngwezi Group Ranch in Laikipia District, where the local people are conservation-minded and protect their wildlife for the benefit of guests visiting the indigenous tribal lands. Little Ilingwezi apparently fell into a deep erosion gully from which the herd was unable to rescue her. Hearing the commotion caused by this tragedy during the night, tribesmen went along to investigate at dawn and found the baby abandoned down the hole.

Unharmed, she was flown to Nairobi that afternoon, arriving in wonderful condition and becoming one of the lucky few who never needed the attention of a veterinarian. Ilingwezi is one of the most gentle and playful little elies, and is a great favorite with the keepers.

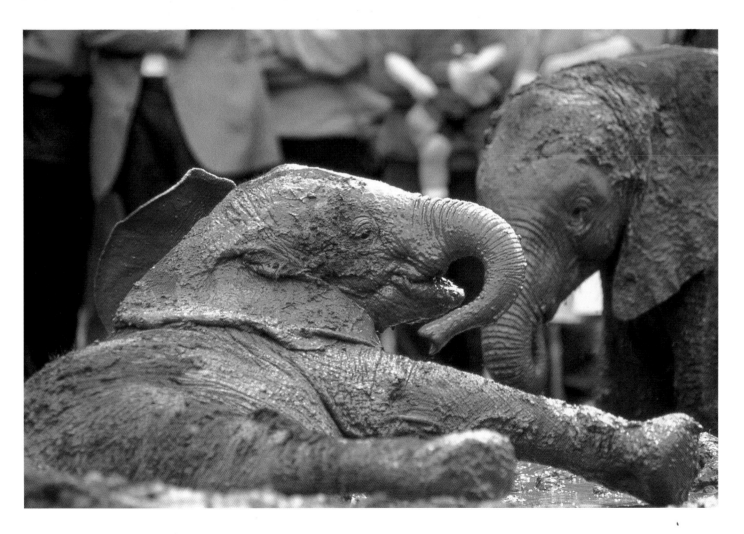

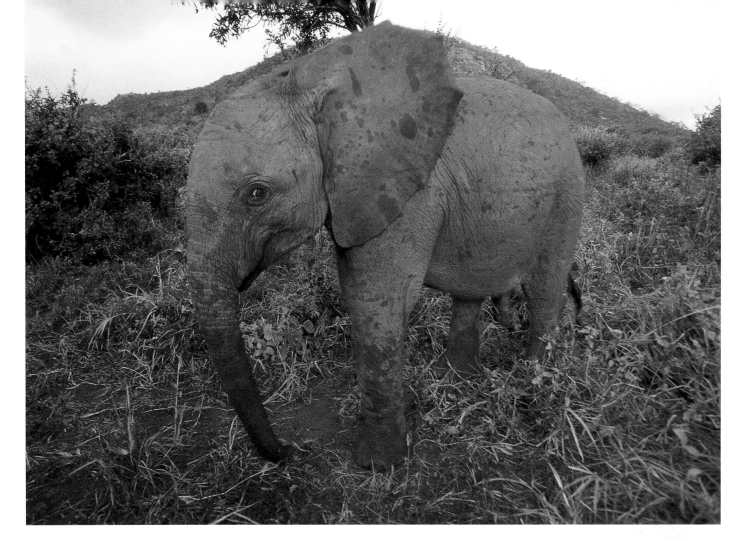

NYIRO

Born: August 1999
Rescued: November 1999
Orphaned after being stuck in a trench in one of the most remote corners of Kenya's Northern Frontier District.

TINY NYIRO was named for an isolated massif known as Ol Donyo Nyiro, which stands in the midst of the vast lava deserts of the region.

He was found stuck in a trench by tribesmen, so the fate of his mother and family is not known. Coming from a population of desert elephants toughened by natural selection, he is a stout and strong little character. The smallest of the Orphan 8, Nyiro is the favorite of all the bigger elephants, especially the older orphan Aitong, who smothered him with affection upon his arrival in Tsavo. This caused Nyiro to dash off

and become entangled in the electric wire surrounding the stockades, so his introduction to Tsavo was anything but pleasant! Nyiro was the first of the Orphan 8 to seek the company of a wild herd, striding up to a wild matriarch that we suspect must look like his mother. With a dreamy look, he planted himself beside her foreleg. He even attempted to suckle her, but she gently pushed him aside.

LOLOKWE

Born: June 1999
Rescued: July 1999
Orphaned at just one month old
after falling into a well on the
Namunyek Group Ranch.

HIS NAME, "Lolokwe," is derived
from that of the area known as Ol

Lolokwe, meaning "faraway moun-
tain." He, Salama, and Nyiro all
have faces that look very much
alike, so it is difficult to tell one from
the other, since they are all about
the same size. It is possible they
were all fathered by the same domi-
nant bull in Ol Lolokwe. Lolokwe
does have one distinguishing

mark—a badly chopped trunk tip.
The poor fellow was attacked by
hyenas while stuck in the well—
luckily only his trunk tip was lost.
Despite early struggles, he has
adapted beautifully and competes
for his equal share of food and
attention with the other orphans.

SALAMA

Born: April 1999
Rescued: late July 1999
Torn from his family because of his birth into the troubled Laikipia population of refugee elephants which have fled from the north due to poaching. They are now constantly in trouble for encroaching upon human settlements and croplands.

SALAMA WAS AN INFANT of about three or four months when he was orphaned. The little bull is probably the only elephant in the world to have been officially "arrested" by irate tribesmen (according to the press) and marched, amidst an excited crowd, to the Kenyan Wildlife Service offices in a local town. From there he was collected and flown to the David Sheldrick Wildlife Trust orphanage in Nairobi. Salama is a tough little customer from a hardened population, and his strength of character is reflected in his confidence among the other calves and the keepers. At times a little pushy, he is affectionately called *mangaa* by the keepers—a Swahili word that means "naughty." The name *Salama* is taken from the village near where he was found.

LAIKIPIA

Born: February 1999
Rescued: February 2000
Orphaned when his mother died and he fell down a well on the Laikipia Group Ranch in north-central Kenya.

LAIKIPIA IS A CALF from Loisaba Ranch in the Laikipia District of northern Kenya. He was approximately one year old when his mother died during a very dry season, from either drought, sickness, or possibly bullet wounds. (The elephants of northern Kenya have suffered enormously at the hands of brutal poachers—one can only guess how many elies like Laikipia are never found.) Obviously, his mother had had very little milk for many months, because when he arrived at the orphanage Laikipia was weak and his skeleton was visible; he appeared to be not long for this world. He arrived in Nairobi late one afternoon, extremely fearful of humans. A younger orphan, Lolokwe, was brought into his stable to help calm and comfort him. Miraculously, the maneuver worked within minutes. Soon afterward, Laikipia was taking his bottle like a veteran, and throughout the night it seemed impossible to fill him up. Amazingly, by the next morning he was part of the gang, out with the other elies and their keepers as though he had always belonged.

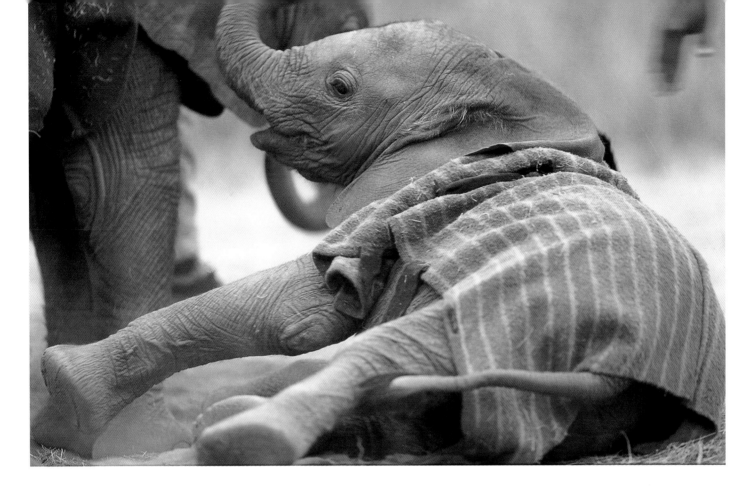

EDIE

Born: April 1999
Rescued: July 1999
Orphaned after falling down a well on the Namunyak Group Ranch in north-central Kenya.

EDIE'S HERD HAD STRUGGLED all night to try and rescue her from the well she had fallen into, but were unsuccessful and eventually had to leave when tribesmen and their cattle arrived. She was rescued and flown to the Lewa Downs Airstrip, where she was collected by keepers from the orphanage and flown on to Nairobi by plane. Edie is one of the few elies to be named in memory of a person—one of Lewa's donors, named Evie. Since the orphanage likes to give the elephants ethnic names that identify their origins, staffmembers suggested the nearest Samburu word to *Evie*, which was *Edie*, meaning "over there," and the family of the late Evie were happy with that. Just four months old on her arrival, Edie grieved deeply for her lost elephant family, but perked up soon after she was introduced to the other orphans. She was very sore and bruised from her fall, and for many weeks could only lie on one side of her body, but she was otherwise not in bad condition and did not need the attentions of a vet—just a lot of tender loving care from both the keepers and the other elephants. Edie and Ilingwezi have formed a strong bond of friendship.

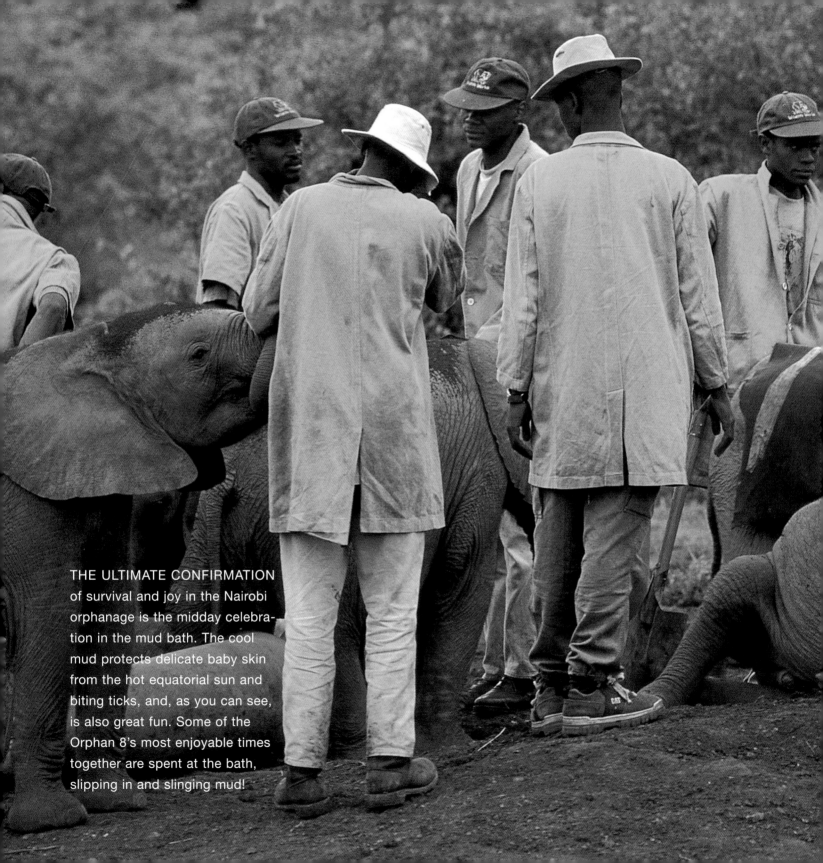

THE ULTIMATE CONFIRMATION of survival and joy in the Nairobi orphanage is the midday celebration in the mud bath. The cool mud protects delicate baby skin from the hot equatorial sun and biting ticks, and, as you can see, is also great fun. Some of the Orphan 8's most enjoyable times together are spent at the bath, slipping in and slinging mud!

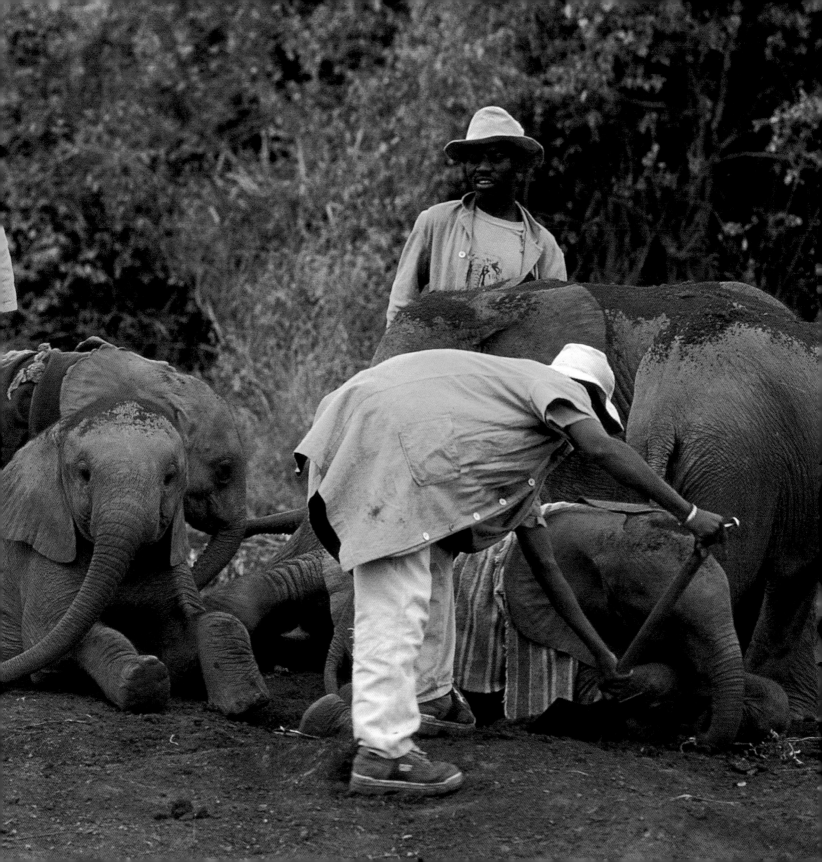

Milk Bottles and Mud Baths

Being an Orphan

ROUTINE ISN'T SOMETHING we immediately think is important to wild elephants. Wandering from bush to bush to feed, zigzagging through a forest, exploring here and there—these activities don't seem to form a routine. But there is one. For elephants, the routine may be daily, annually, or, as we are coming to understand, may stretch over decades and may adjust for drought, changes in river flow, vegetation growth patterns, and more recently, human settlements.

In the days after chaos strikes, efforts to reestablish a baby elephant's routine become paramount to its survival. After stabilizing a baby's physical health, it is critical for the staff to begin addressing its need for predictability in its environment. Each day in the orphanage begins the same way and includes the same set of events: The elies get milk bottles every few hours, take a midday mud bath, and at day's end line up single file behind a keeper and march back to the stables to bed as if he were their matriarch. Any parent could follow the routine, but likewise, any parent can tell you that no two days are ever the same. And so it is raising elephants.

Raising human children is, well, easy by comparison. After all, we are the same species and they are our offspring, so by and large they should walk, talk, eat, and sleep as we do. But for Daphne, Jill, Mishak, and the other keepers, bridging the gap between human parenting and elephant parenting takes rethinking. The basic elements of sensitivity, love, nurturing, and endless patience apply to rearing any baby. Elephants, like humans, enjoy long lives, but they share many other attributes as well. The parallels are fascinating on the surface, and astonishing once you begin to dig deeper. Baby elephants arrive in the world after nearly two years of tumbling in a warm amniotic sea. When it emerges, to enormous attention and celebration by the mother's family herd, the little elie is virtually helpless. Over the next days and weeks, the baby strengthens the bonds to its mother and to its new aunts, sisters, and grandmother that will unite them over the next 60 years of her life. That first year is when she learns the elephant basics. For the orphans this critical year is an important test of their surrogate mothers' capacity for love and understanding. And in this new herd they now have two matriarchs, wise grandmother Daphne Sheldrick and mother to all, Mishak Nzimbi.

During the months the Orphan 8 and other orphans arrived at the orphanage, the combination of a changing staff and the huge influx of new elies made establishing a routine doubly

difficult. In addition, construction of a costly new set of stables was under way. With a deluge of babies the likes of which the orphanage had never before experienced, space was at first tight, then at a premium. Finally it ran out. My hopes of following one—perhaps two—orphan elies from their early days to eventual release with the older orphans in Tsavo (West) National Park suddenly changed. I found myself instead documenting a collection of dedicated people as they tried to cope with the chaos of environmental issues beyond their control: prolonged drought, renewed poaching activity, harsh action against problem animals, and strange mishaps—all of which manifested as emotionally and physically distraught trunk-wagging baby elies.

Replicating the proper everyday world for a wild African elephant is a large task. Daphne's success was made possible in large part because of the years she spent in the bush alongside her husband and head park warden David Sheldrick. The wilds of Tsavo Park, where they lived, were widely known as the greatest elephant country in all of Africa. There, herds of over a hundred animals were common before the ivory-poaching slaughters of the 1960s and 1970s began. At one time, the Tsavo parks—which combined are approximately the size of Michigan or Germany—were home to as many elephants as now roam the entire continent.

When infants arrive at the orphanage, they are introduced to the other resident babies as their health will allow. A highly social being, an elephant's perception of the world, like a child's, is molded in youth and by those who surround it. For the orphans, this means they have a disoriented foundation. Depending on where they were separated or lost, the Trust orphanage may be too hot or too cool, or have the wrong soil type, the wrong vegetation, and foreign sounds and smells. Combine that with the fact that the milk they are being given is not their mother's, and these babies find themselves in an entirely new and unfamiliar world. For this reason, a new orphan is given constant attention by two to three keepers who remain with it at all times of the day and night.

New babies are the focus of both human and elephant attention. The established orphans are infinitely curious about the newcomers. Over the years, Daphne and her daughter, Jill, have learned that introductions to the other elephants shortly after a new arrival, especially by a slightly older female, often prove a settling experience. The introductions also quiet the established

orphans, who are extremely sensitive to the sounds and smell of the new one. But the speed of each introduction depends on the age of the newcomer, the circumstances of its being orphaned, and the trauma of its rescue. Some babies take weeks to adjust to orphanage life—and not every orphan's story is filled with joy. Over the years that I followed the Orphan 8, the cast changed several times. In fact, for most of her first year, Natumi, who now leads the Orphan 8, was second in rank behind a sprightly little female named Maluti. From the first day I met Maluti, I loved filming her. She was always active and eager to show her dominance. She was 11 months old and at an age when everyone thought her survival was all but guaranteed. But one night, without warning, she began discharging blood and soon died. An autopsy revealed a chronic lung condition that likely originated as a result of mud she inhaled while trapped in a waterhole in Meru National Park with only her trunk tip snorkeling above water.

For the babies of the Orphan 8 the circumstances in the orphanage were very unusual. At no other time had so many little ones romped about the grounds. There were constantly elies in motion. One oddly quiet afternoon after the midday mud bath we were back in the small forest. I looked about and all the babies were asleep and all the keepers were resting. I looked across at Mishak and smiled, and he returned a smile of acknowledgement; for a moment we were both remembering the days when only three elies were on hand—how very quiet those days seemed now.

The abundance of babies insured that everyone had a playmate—but it also meant that someone always seemed to be hungry. Milk bottles were ferried nonstop between the orphanage and Daphne's carport (which has long doubled as a milk mixing station). In the forest, it constantly looked like laundry day, with nursing blankets hung everywhere. Meanwhile, herd dynamics were already beginning to surface among the babies. Natumi was taking the lead, and Edie and Ilingwezi were close behind. At 500 to 600 pounds each, they gave new impact to their pushing games and shoving matches. The Orphan 8 were clearly settling into a routine and building an identity as a group. Still, every day remained unique....

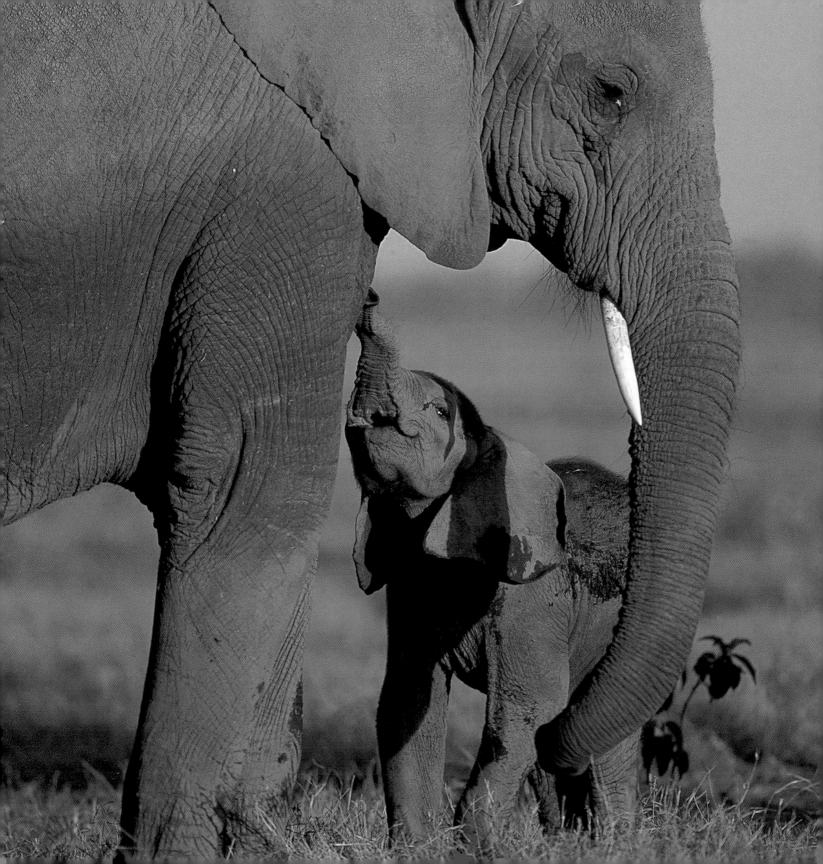

A HUNGRY BABY ELEPHANT first seeks approval from its mother to nurse, then searches for a nipple. Then, once it has drunk its fill, it runs off to play as if it were never hungry in the first place. Regardless of who is accepted as mom, the signs and sequence are the same. A wild elie in Amboseli N.P. **(opposite)** begs his mother for attention and access to her breast. Arching his trunk high and aiming for mom's neck is common, and receives an immediate reply. Likewise, orphans show the same behavior to their "moms" **(below)**: in this case, Mishak deals with the complication of dual begging. Orphans seem to get additional reassurance by sucking—pacifier style—on their keepers' fingers. This can prove dangerous if you allow them to suck in your fingers palm-side down. I discovered this the hard way when, with no heel of my hand to use as a brake against the upper lip (base of the underside of the trunk), my finger was quickly drawn to the young molars and chomped— breaking my finger tip! A mistake I never repeated.

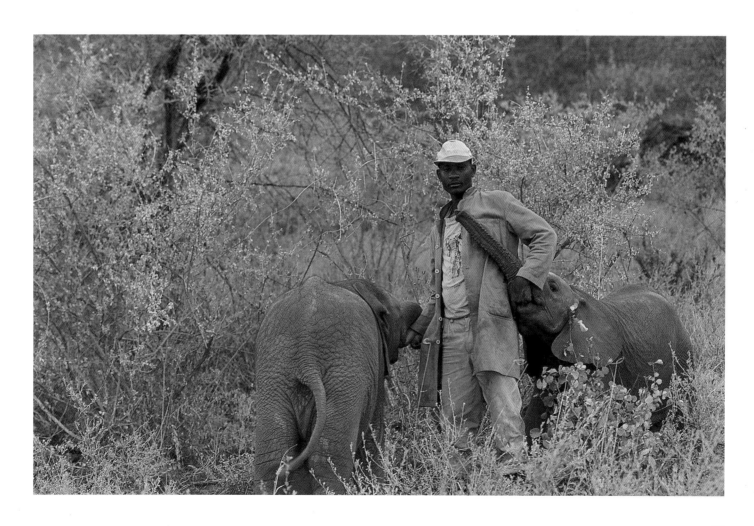

SUCKLING CAN COME only after the baby finds the nipple—something that's more difficult for the orphans. Many little elies have had weeks to become comfortable with the scent, shape and feel of their mom's nipples. But the orphans are now faced with food that comes from a foreign-feeling nipple. On top of all the other traumas they are suffering, this can be frustrating at best, and life-threatening at worst. Some keepers have a special knack for coaxing traumatized babies into accepting the bottle. Among these, senior keeper Mishak Nzimbi is unique. "Mishak's magic" has saved more than one troublesome orphan. Edwin **(right)** is a quick study of the "magic" touch needed to entice an orphan to drink its first bottle.

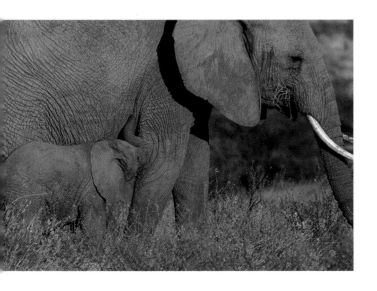

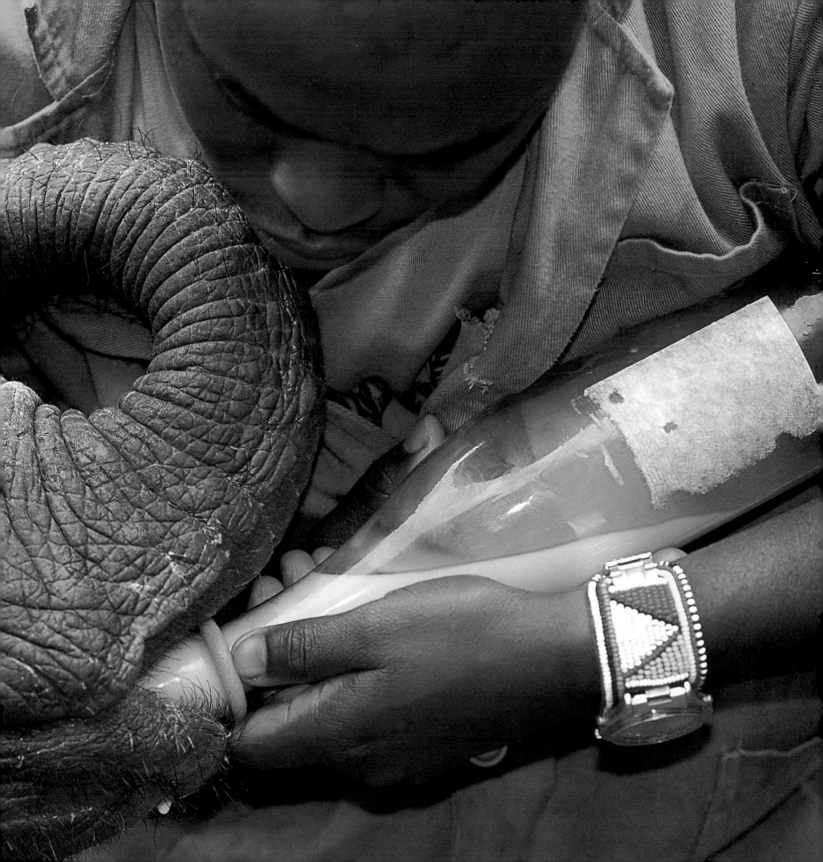

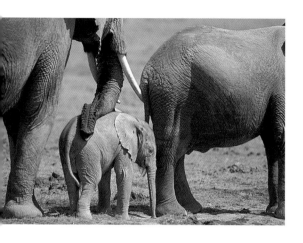

NOT GIVING ENOUGH reassurance is "one of the mistakes we made in the early days," says Daphne. She can be forgiven; she was going where no one had gone before. What no one understood—until Daphne paved the way—was the degree to which infant and young elephants require contact, especially during feeding. The solution—hanging a thick wooly blanket for the baby to nestle up against, simulating a mother's contact—is simple in hindsight, but improved survival chances dramatically. Blankets are now a constant element of the orphanage landscape. They go with the babies everywhere. On cool winter mornings, blankets also provide the extra warmth to prevent cold-like symptoms. Morning temperatures in the foothills of Nairobi National park can dip into the low 40's F (4–5°C).

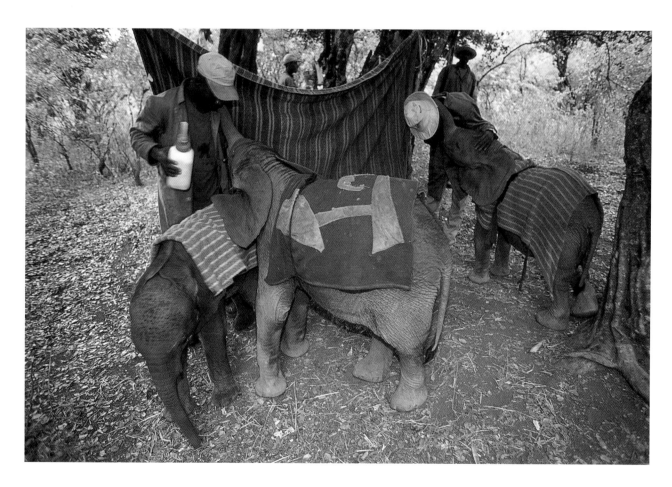

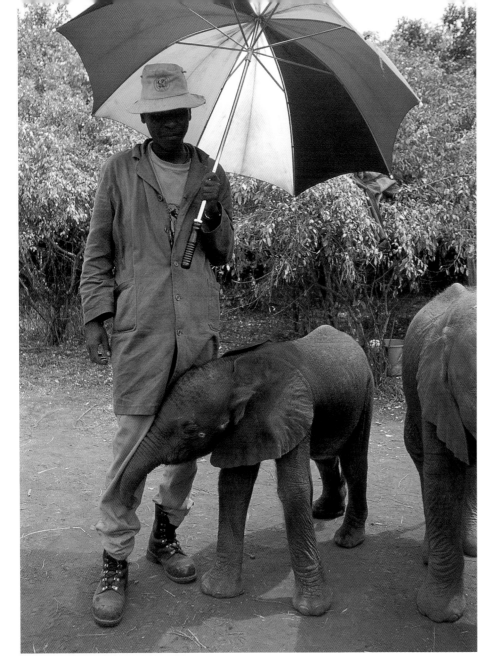

skin is incredibly sensitive and susceptible to damage, especially tissue around the ears, face, and trunk. Wild herds are careful to protect their babies —especially newborns—from the weather. In the hot African sun, sunstroke and sunburn can cause death or skin damage in a very short time. Little elies conveniently slip under larger family members or are always positioned neatly on the shady side of their mothers. In the orphanage, keepers lack the bulk necessary to create those ample puddles of shade, so they turn to large golf umbrellas—practical, but also delightfully whimsical. Imagine trying to chase after a small child who is intent on playing instead of quietly standing in the shade.

AT FIRST GLANCE, it is almost impossible to believe that cold or sunburn can kill an elephant. Their skin appears rough and tough— impermeable to all the elements. As a baby, however, an elephant's

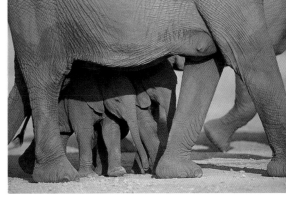

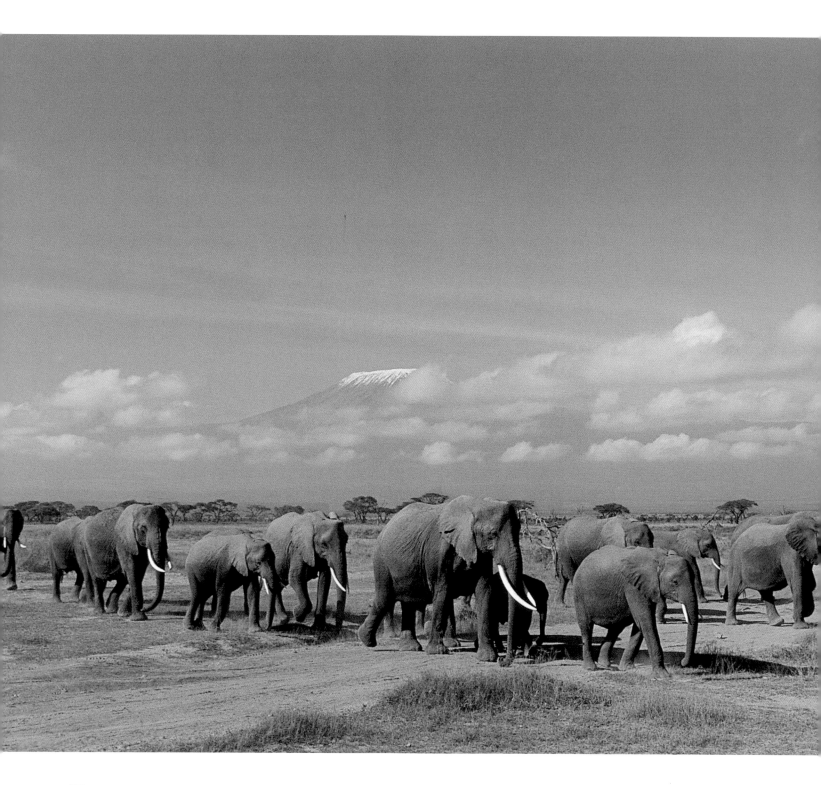

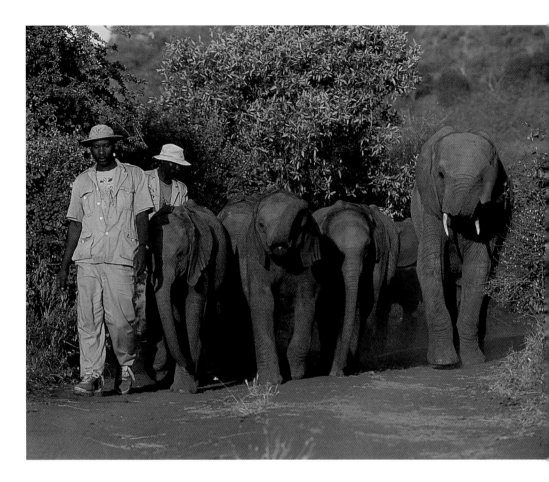

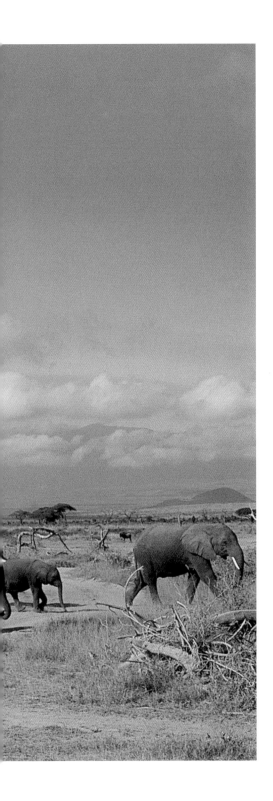

NO OTHER ANIMALS on Earth build their lives so tightly around their immediate and extended family members than elephants do—not even humans. To an elephant youngster, the tight community of the matriarchal herd into which it is born represents safety, food, knowledge, and a link to the past. Their reality is shaped by their childhood experiences in the herd. Replicating that reality for the orphans is a for-midable task for their keepers. Head keeper Mishak Nzimbi leads the Orphan 8 **(above)** and older orphan Aitong (on the right), on their morning walk to begin another day in the bush. Mishak is clearly seen by the babies as their surrogate matriarch, and in his gentle, confident manner exudes enormous influence over them.

AS THE ORPHAN 8 get older and form a tight herd of their own, late afternoons assume a very wild manner. Wild elephants have a lazy way of moving casually through the bush, eating, playing, exploring, and covering a surprising distance. The Orphan 8 also begin moving as one through the meadows and thickets surrounding the orphanage, but always stay close to their keepers.

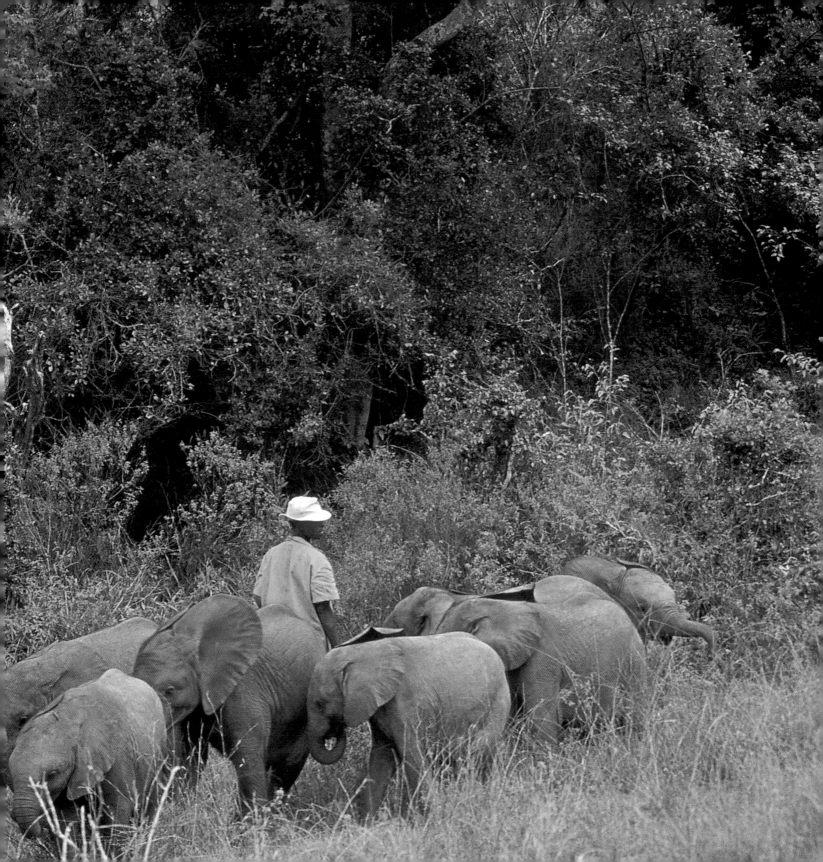

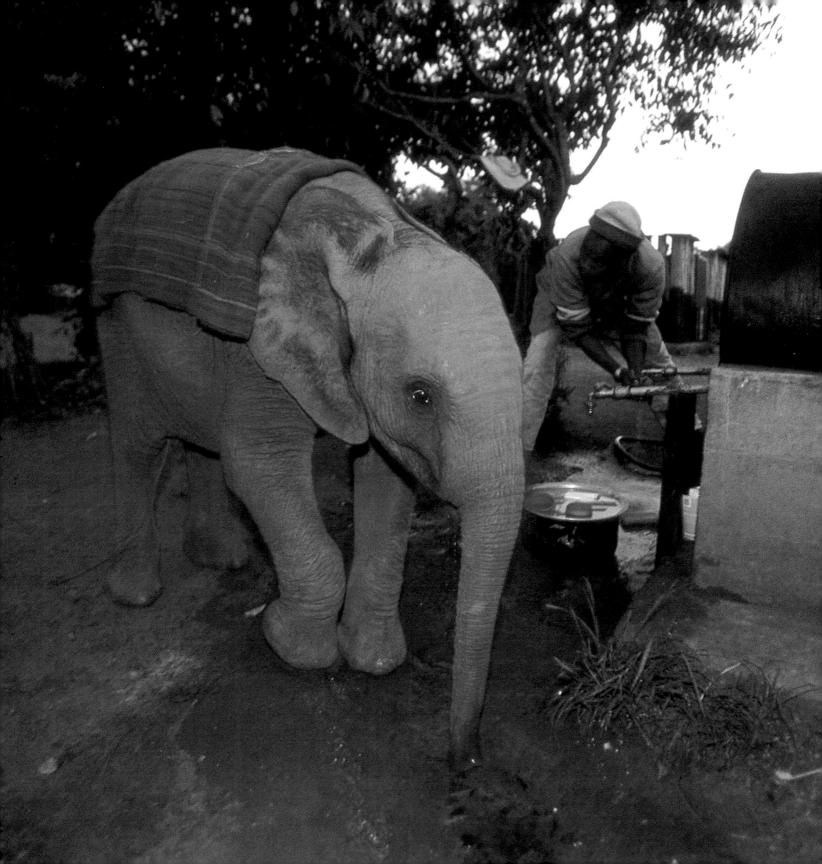

THE DAY STARTS before sunrise, often after a night of little sleep for both elies and keepers. Orphans receive a bottle of milk before they are set free from the stables. Like small children they are full of energy, impatient to discover what has happened to their world overnight. Despite resting less than a degree south of the equator, the Nairobi orphanage is quite cool and cloudy in the early hours. Once out in the bush, the keepers build a tiny fire around which they cozy up with their charges **(right)**. After a flurry of early activity, the rhythm of the morning often slips into a quiet time of bonding between elies and keepers.

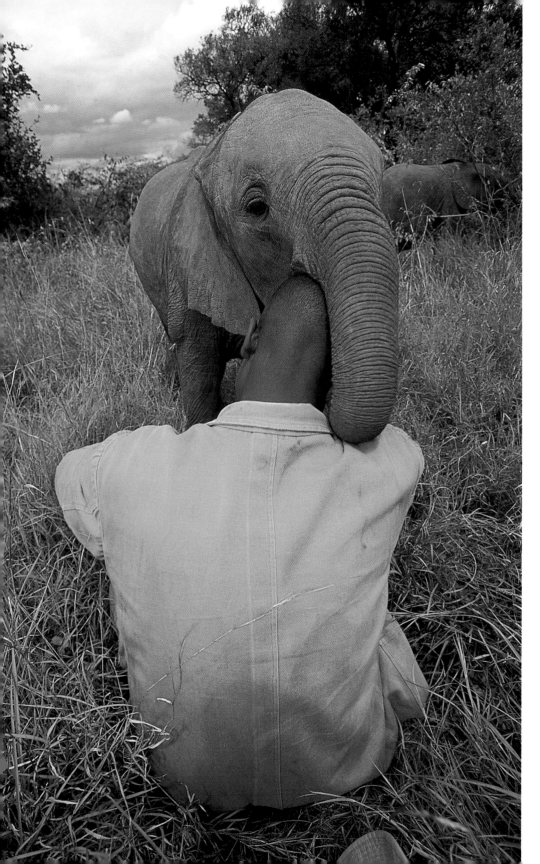

THE ENDLESS PATIENCE of the keepers is always a marvel to me, but it is surpassed by their genuine caring for their tiny charges. As the elies grow older, each develops a particular bond to a specific keeper. In the quiet afternoons when we return to the forest clearings, that affection becomes nearly consuming **(opposite above)**, especially as the orphans get larger. Julius Latoya's shaved head becomes a favorite mouthing toy for Nyiro **(left)**.

Physical contact is a natural part of a baby elephant's upbringing, and keepers are obliged to be equally physical. Wild elephants are in constant contact with little ones, partly out of safety concerns and partly because they are babies. Between the keepers and the elies, the affection flows both ways. Occasionally, more than one baby will demand the attention of the same keeper **(opposite below)**, in this case Mishak, and a shoving match ensues. I have spent many hours photographing keepers lovingly playing gentle touching games with a dozing baby trunk or ear. During these quiet times, the keepers bond with the babies much the way a parent bonds with his or her own children.

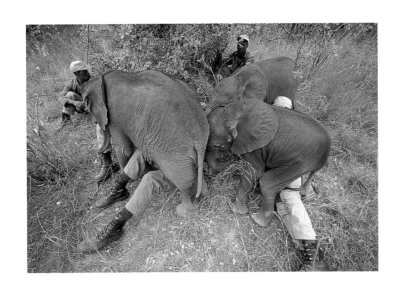

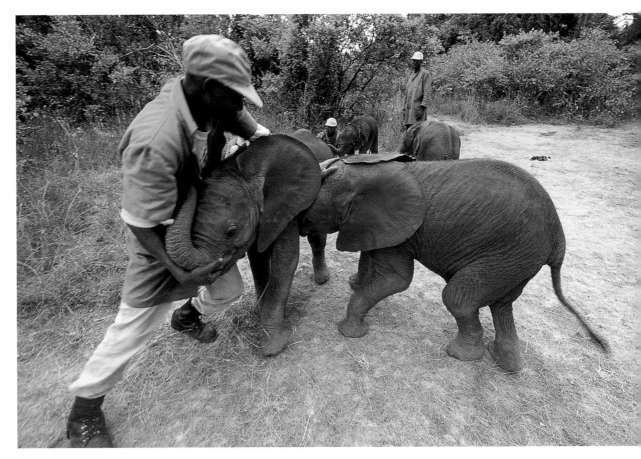

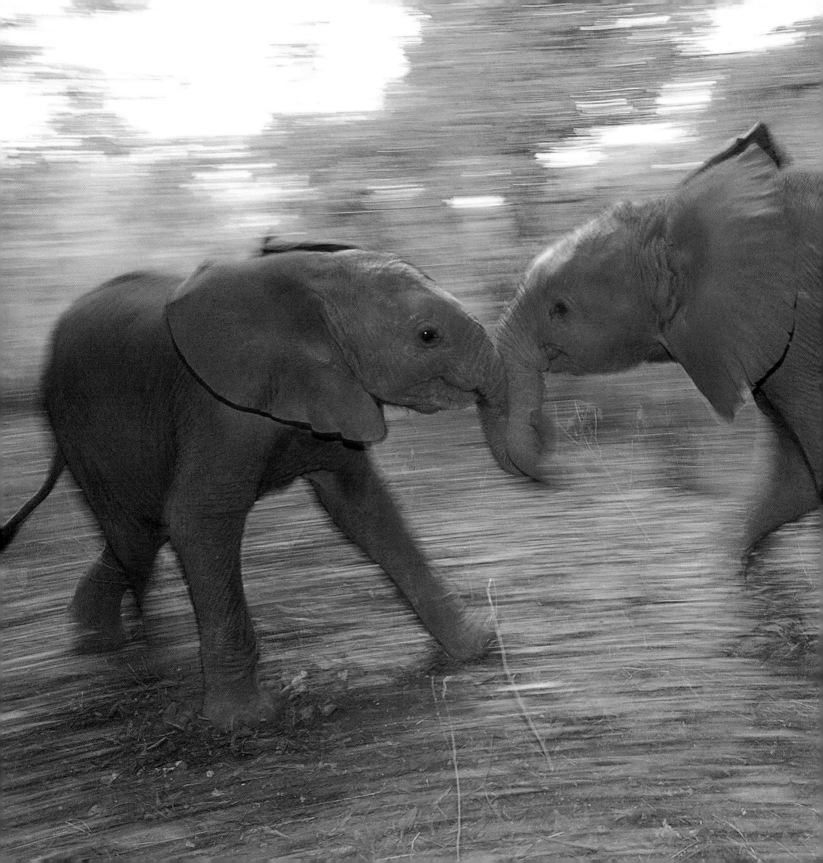

HEAD AND TRUNK pushing matches increase as the babies grow older as a means of asserting their positions in the Orphan 8 herd. Here Natumi and Ilingwezi push each other about with all 1,000 pounds of their collective weight engaged. But the match lasts only a few seconds. If they go at it any longer, Mishak's stern voice commands, "No pushing, no pushing."

I once told him I wished someone would pay me every time he said "No pushing." I would be a very rich man.

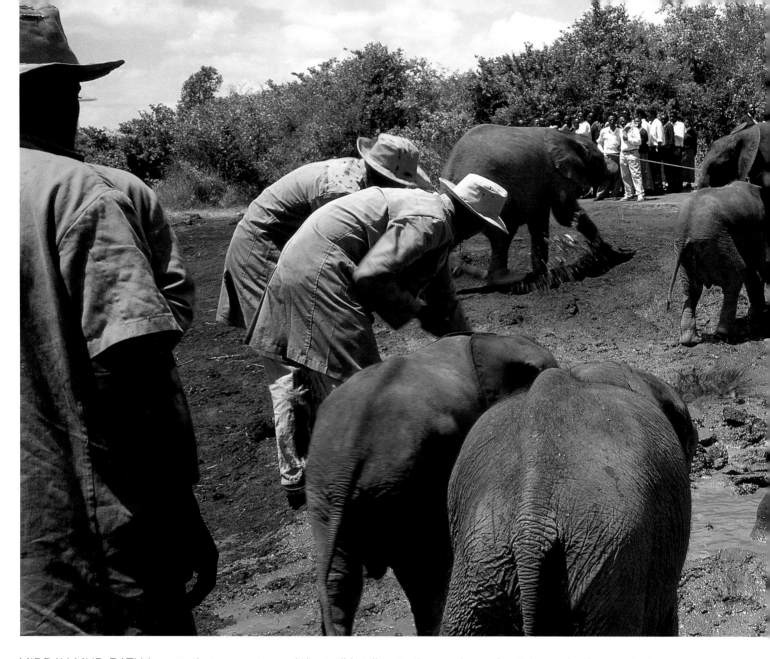

MIDDAY MUD BATH is a routine the babies adjust to quickly and maintain even after they are taken to Tsavo. In fact, it's a routine they learn to look forward to with such zeal that I often see the babies gather on their own and inch toward the trail leading to the mud bath area. Mud baths serve two important functions. The orphans learn the value and technique of coating their skin with a layer of wet mud, which cools them in the heat and provides a thick crust difficult for ticks and other pests to penetrate. Secondly, playing in gooey, slick, red-clay mud is just plain uninhibited fun! The mud bath also is the only place where visitors and schoolchildren have to see and learn about wild elephants on a

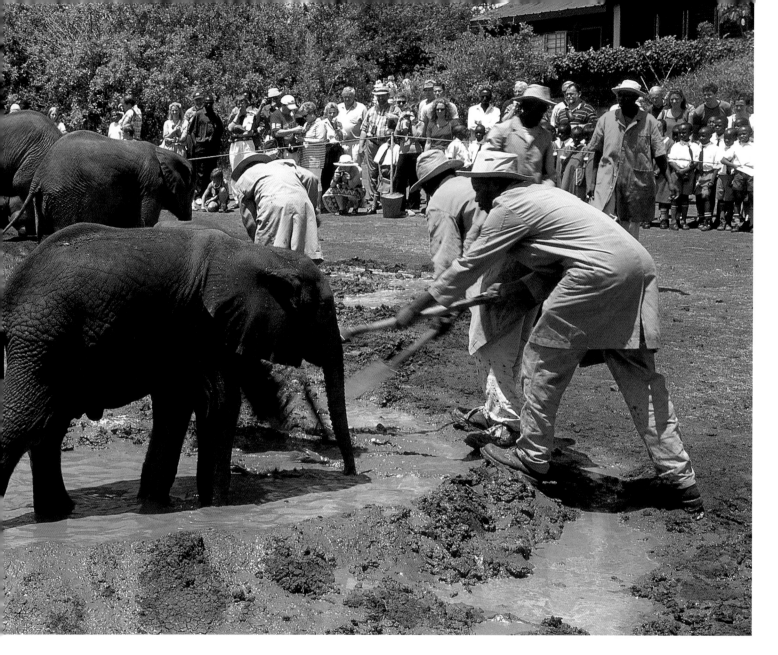

daily basis. A small platoon of volunteer docents inform the visitors who gather behind a single rope as to the "whys" and "wheres" of each elie toddler's life. Most important, the mud bath brings many visitors face to face with the realities confronting Africa's elephants. Finally, for a trust that functions solely on the generosity of visitors, the daily attraction and appeal of the orphans generates just enough income to keep the babies fed, housed, and cared for.

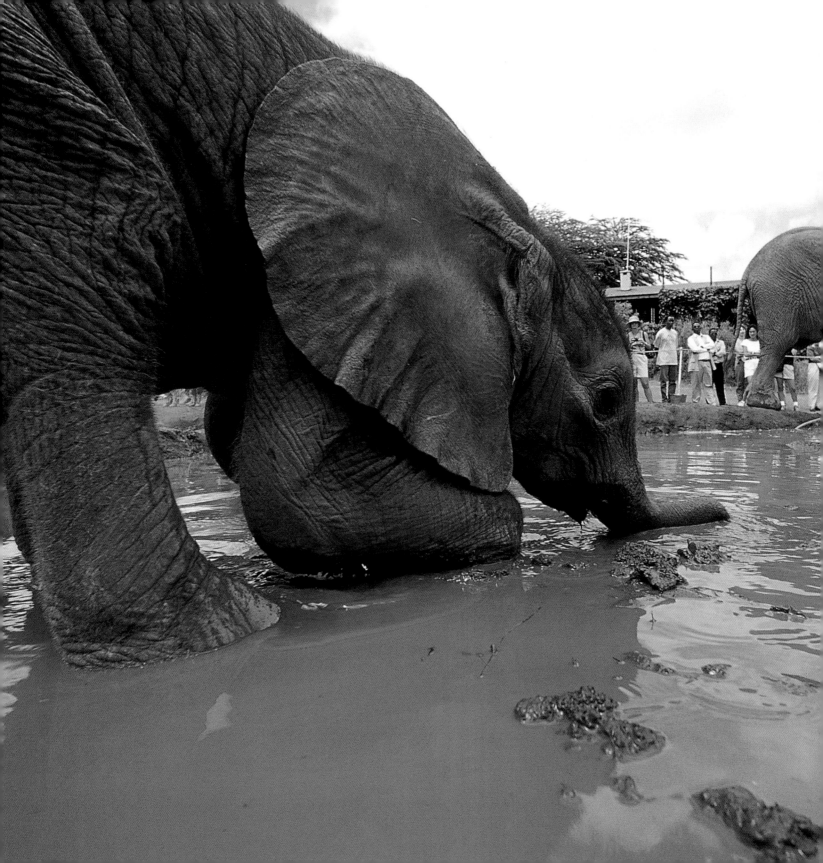

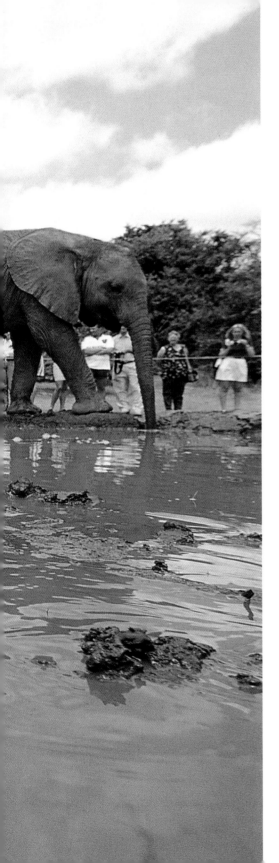

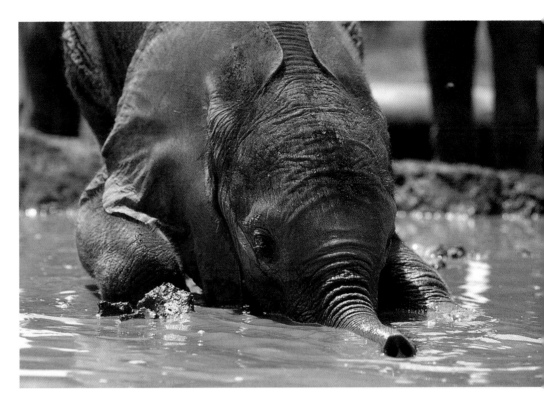

MORE THAN ANY OTHER baby elie, Icholta seems to delight in the cool, soupy mud at the midday bath. She is more often than not the first to plunge in and last to exit, and loves wallowing about in between. Many of the other Orphan 8 are reticent to embrace the mud bath at first, and need coaxing by the keepers. I often think this might be due to lingering memories of being trapped in the mud and abandoned. But Icholta is a victim of mud whose spirit has never been dampened by it.

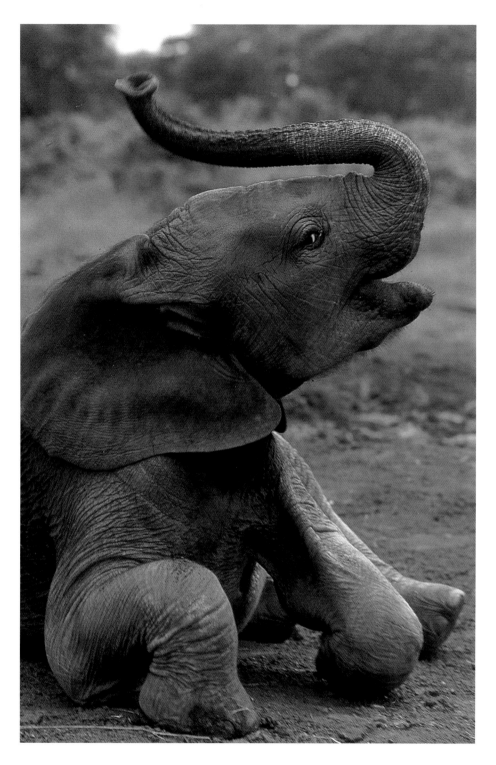

THE JOY OF THE MUD BATH seems almost beyond words. Elies large and small rear their heads back and toss their trunks skyward **(left)**.

I have never grown tired of watching the little elies frolic in the red-clay mud. Getting started is often a problem, but with the encouragement of the keepers, who toss buckets of mud onto them, each orphan soon joins in. Once they are dripping and slipping about in the bath's central wallow, they appear to be in sheer ecstasy.

A year after this photo was taken, I watched a wild herd of 15,000-pound bulls ease into a mud wallow and rejoice in the same way!

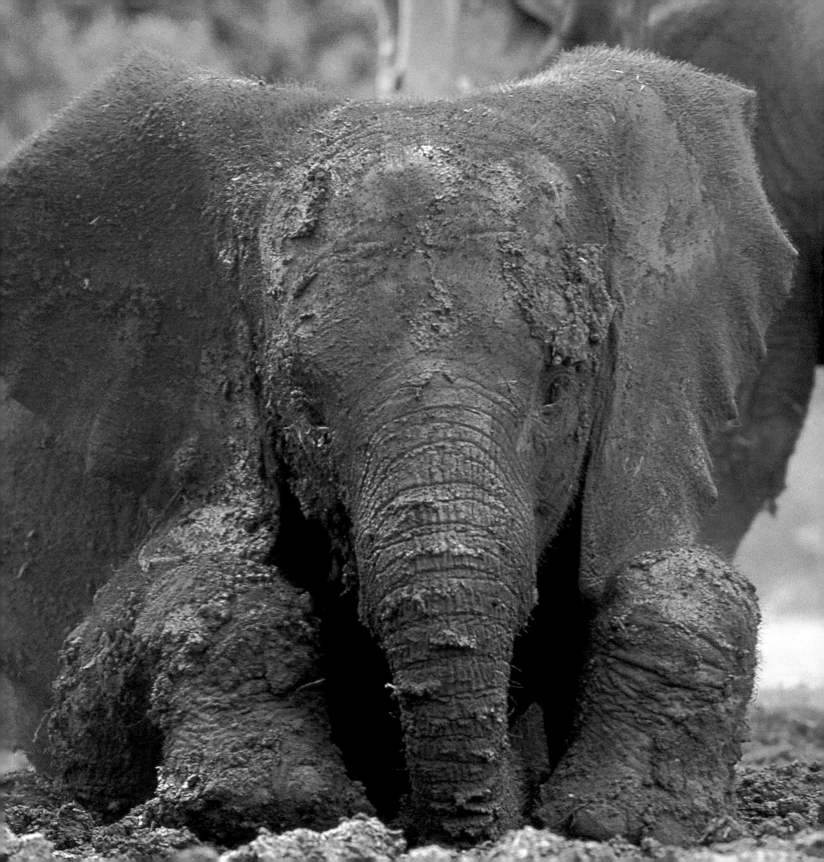

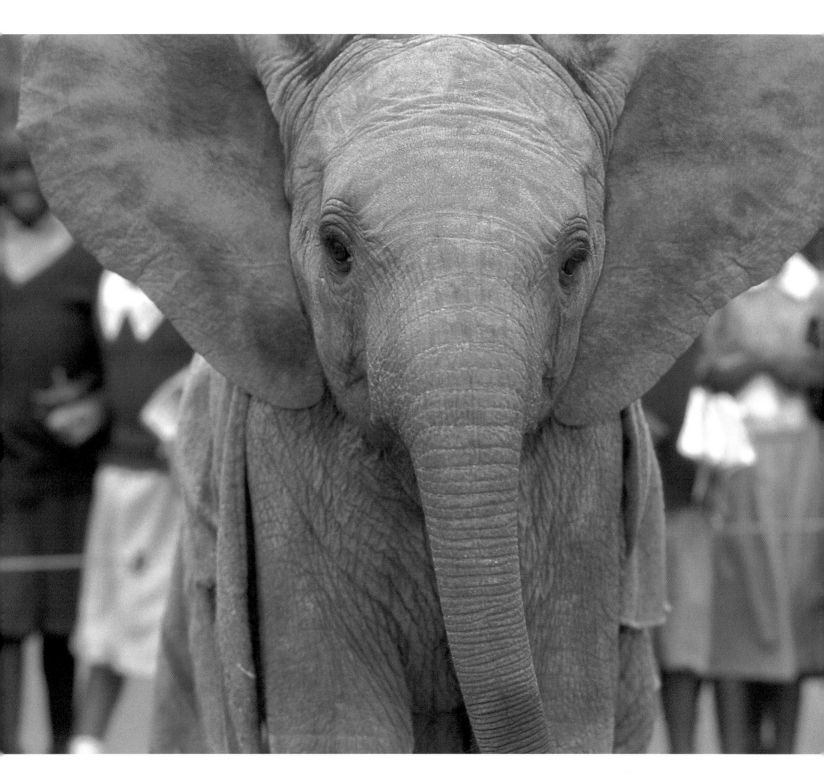

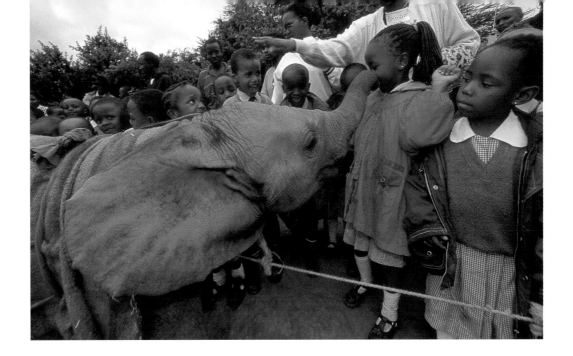

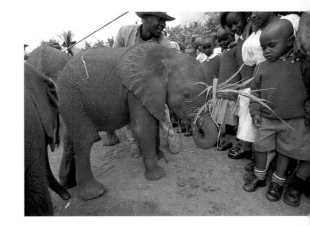

FOR MANY of the local children, school visits to the orphanage during the midday mud bath are their only exposure to the indigenous wildlife of their own country. Kenya, like many countries around the world, is under enormous pressure to meet the needs of a growing population and their demands for development. African elephants need large expanses over which to roam and feed. Finding the balance between humans and elephants is the ultimate challenge. Ironically, the very reason these kids can watch and be delighted by the antics of a baby elephant is because elephants are being threatened by increasing human growth. Over the past decade, several tens of thousands of Kenyan children have had their first and only glimpse of an elephant at the orphanage mud bath.

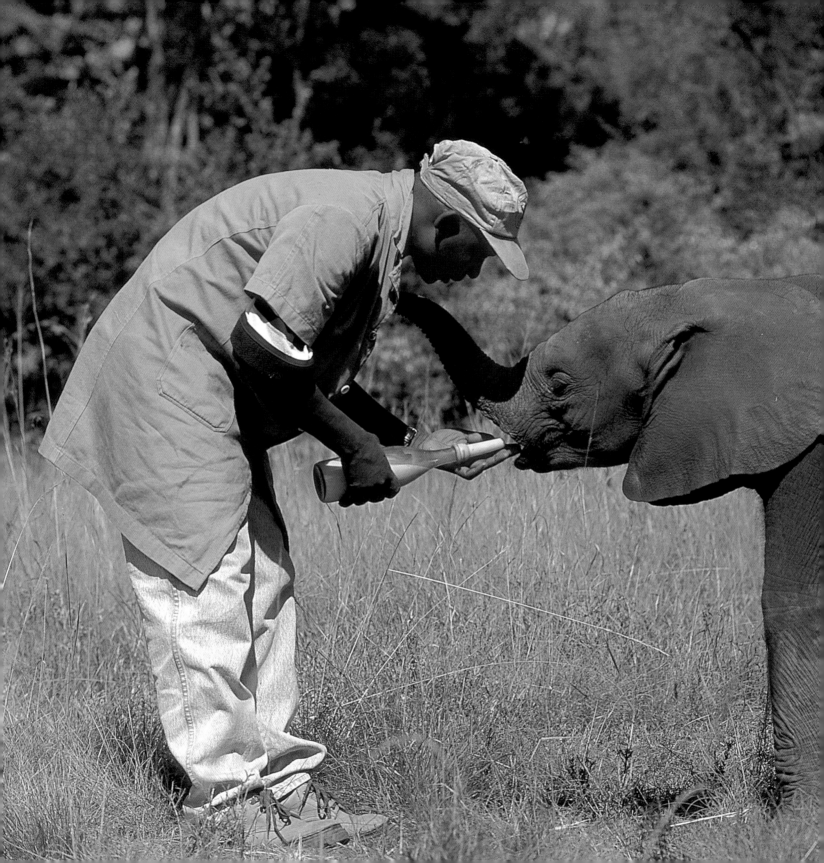

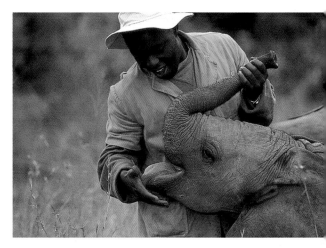

"MISHAK MAGIC" works time and time again **(left)**. Once rescued and brought to the orphanage, the danger is not necessarily over. Days—even weeks—of constant attention by the keeper staff must be given to the new orphans. Mishak is often the only person capable of coaxing resistant orphans into accepting the artificial milk and bottle. Their survival is often dependent on it. Some of the keepers believe "Mishak magic" is more than just gentle hands and a welcoming heart; they credit his "elephant spirit." Edwin **(above)**, with the orphanage only a few years, also seems to have "elephant spirit," and has become a favorite with many of the newest orphans.

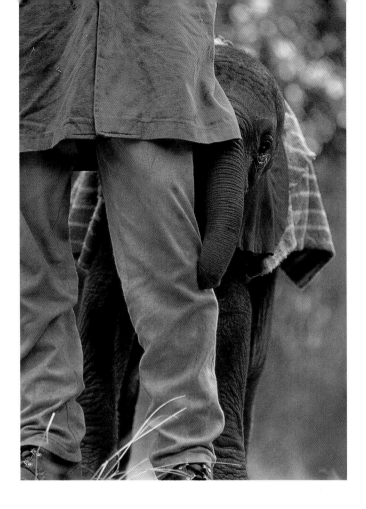

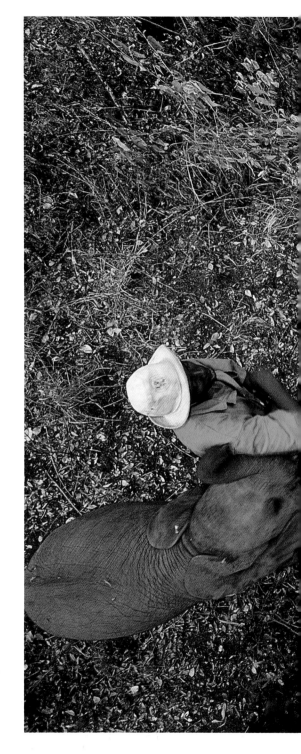

FIRST DAYS at the orphanage for new arrivals are traumatic and frightening. Natumi has since worked her way into the wilds of Tsavo N.P., but here, her first days in the Nairobi orphanage **(above)** are filled with trepidation. She develops an immediate fondness for Mishak and seeks his comfort at the slightest hint of danger. A shy little girl, she uses his legs as shelter and peeks out at anything unfamiliar.

As she grew older and larger, Natumi also grew more independent, but on those rare occasions when fear strikes, she rockets back to her old shelter, tossing Mishak airborne in her haste to slip underneath him!

Every elie develops a keeper of choice. From a treetop vantage point one afternoon **(right)**, the relationship of elie to keeper becomes a beautiful pinwheel, neither human nor elephant—but living creatures at home in one another's company.

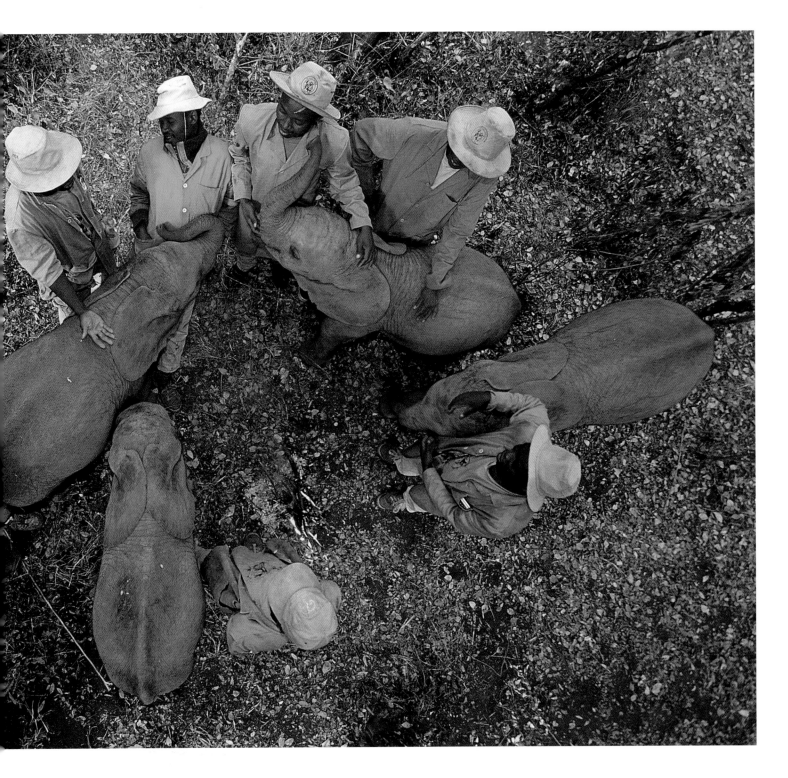

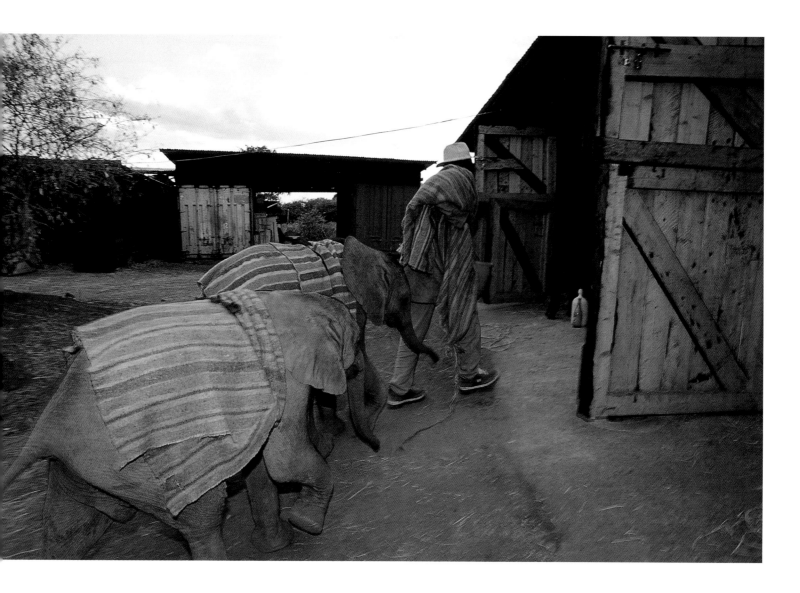

EVERY EVENING the blanketed elies return to the stables. As part of the routine, the babies quickly learn which stable is theirs and run direct-ly to it upon returning from the bush. Within the orphanage compound there are several blocks of stables, as well as larger corrals for orphaned black rhinos. Each stable houses one orphan and one keeper for the night. Since the flood of orphans in 1999, the orphanage has been forced to grow substantially, placing considerable financial hard-ship on the Trust.

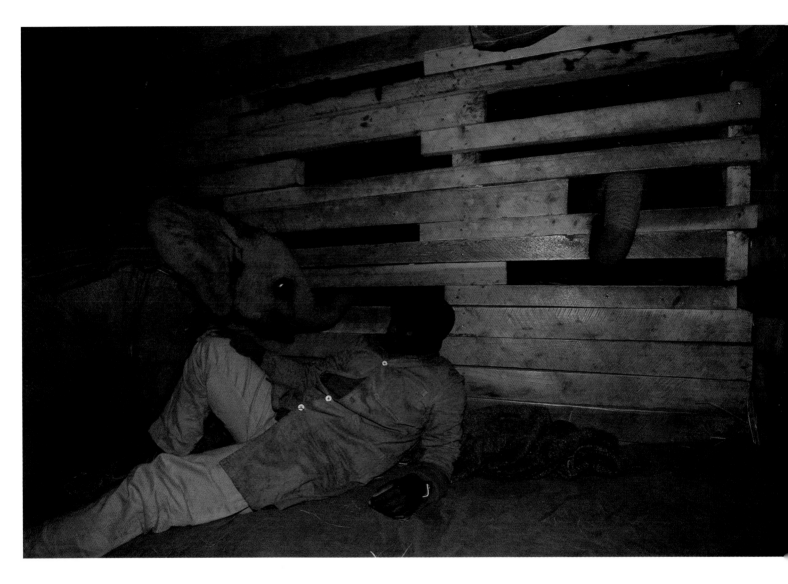

EVEN AT 2:00 A.M., peaceful slumber is rarely the order of things. Trunks can slip and search between the wooden slats of the stables, so once one baby is awake it often means others are as well. If a baby is restless, a keeper never sleeps. In the wild, elephants slumber at night, move a little, and feed. But only during droughts or other hardships do they generally cover great distances. So, unfortunate though it may be for their keepers, it's natural that a baby would not sleep through the night. A keeper's nights are often weary ordeals. Even when a night goes smoothly, there are still regular bottle feedings every few hours.

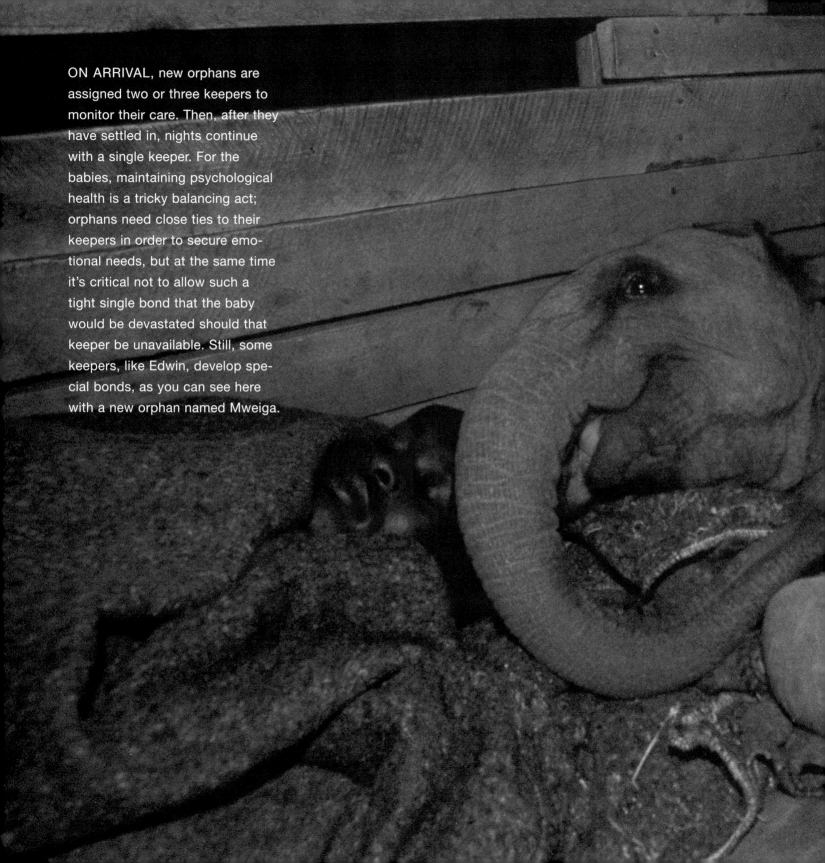

ON ARRIVAL, new orphans are assigned two or three keepers to monitor their care. Then, after they have settled in, nights continue with a single keeper. For the babies, maintaining psychological health is a tricky balancing act; orphans need close ties to their keepers in order to secure emotional needs, but at the same time it's critical not to allow such a tight single bond that the baby would be devastated should that keeper be unavailable. Still, some keepers, like Edwin, develop special bonds, as you can see here with a new orphan named Mweiga.

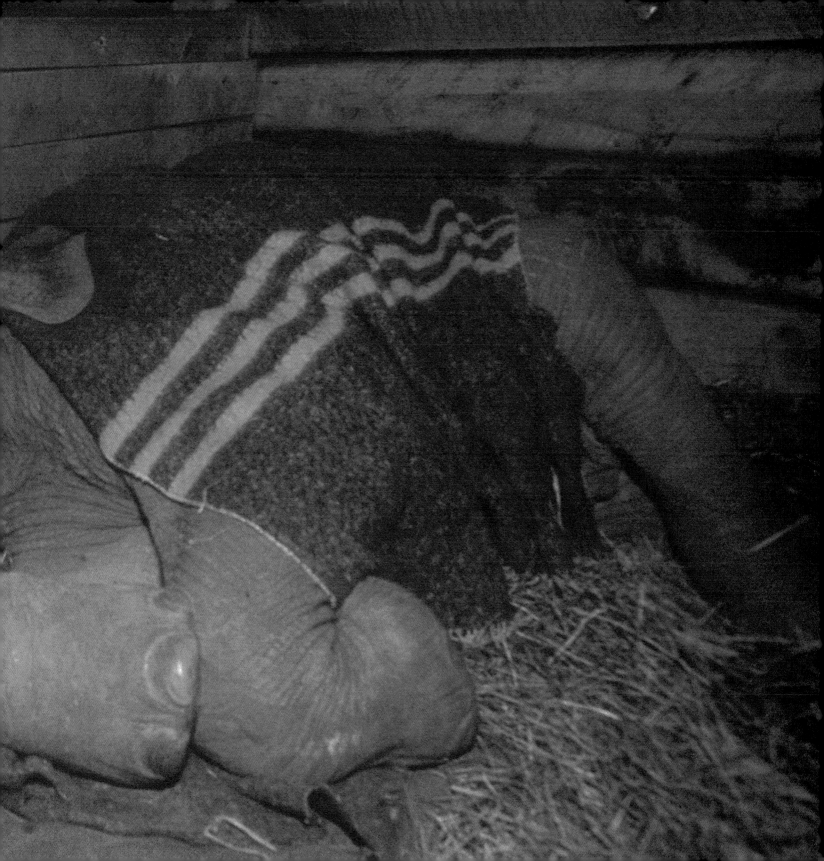

Laibon's Story
Joy and Sadness

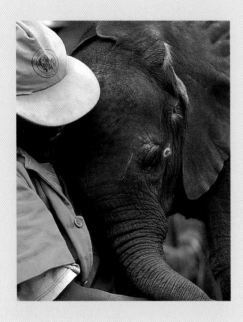

The story of Laibon represents the joy and the sadness of caring so deeply for tiny fragile lives. When they make it, the joy follows you every day in the form of a curious snaking trunk attached to a roly-poly little character that is all spunk and spirit. When they don't, you are reminded that life and death are neither fair nor just, they just are. What follows as Laibon's story, as I wrote it in late 1999, only a few days after I saw him last.

LAIBON CAME to the orphanage in late June, just before I started. For me, he symbolized this project, and I embraced him as my mascot. I immediately began fantasizing about a second book that would follow Laibon into the wilds of Tsavo, where, as a majestic bull, he would triumphantly assume a prominent role in the comeback of the herds.

From the start, Laibon captured my heart. He arrived in the world in the most incongruous way: born prematurely on a dusty sun-baked road. Laibon's mother had stumbled into the path of tourist vehicles and panicked. My guess is that she put on a pretty good show: charging and trumpeting, thereby drawing more vehicles. The excitement brought on early labor, and Laibon was delivered, still embraced in the safety of his amniotic cocoon, onto the dirt road.

Later, officials arrived and determined that Laibon's mother was "a problem animal." Based on the fate of other problem animals, she was most likely shot. And during all that time, blanketed in the membrane of his birth and unable to move, Laibon's tender skin was burning in the sun.

Arriving at Sheldrick's, Laibon had the characteristics of a baby born too early: His skin was dark; his head and ears were covered in a noticeable amount of hair; he had no protective pads on his feet; and he retained an extra set of elfin ears. What we don't know about his life in his early hours was hidden in his wobbly walk. Jill Woodley, Daphne's daughter, could only guess. "It could be in his brain, or there," she said, her eyes scanning his trembling hind leg, "or in his spine. We just don't know."

Laibon means "witch doctor" in Kiswahili. He was given the name because everyone knew he contained magic. To me the magic was evident in his determination—he refused to surrender to death.

One afternoon, as I sat on the ground next to him, Laibon slipped and dropped onto his chin, and struggled to get up. During times

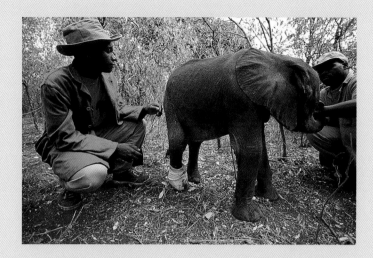

The keepers would walk him less than 20 meters each day—and for this distance he struggled on three legs. Finally he was confined to his stable, his leg nearly double in size. Most of his time was spent lying restlessly or fighting to stand. Now a painful decision needed to be made. Laibon's foot could be amputated, but to do so would mean he could never return to life in the wild. Mercifully, the poison in his leg—probably from a snakebite—made the decision for everyone.

On November 24, 1999, a life that had begun in so much chaos and pain was released from it.

like this, when he tried valiantly to rise to the challenge, my heart would soar. But more often than not, Laibon required help to stand. There were days when standing was simply too much for him, yet for weeks he persevered, even making it to and from the mud bath, albeit ever so slowly and clumsily.

Finally, Laibon's legs appeared to recover. The blisters caused by sunburn were shriveling into scars. He even started jousting a bit with the other orphans—establishing himself with a firm forehead shove and an ear-aching roar that seemed to erupt from an origin of remembered pain deep inside. He was on the mend.

But when I returned a few weeks later, Laibon was hobbling again. His leg was swollen and draining fluid, and no one knew

why. It was clear his battle to survive was far from over. Three keepers stayed with him around the clock. He could never stand successfully enough to drink milk without help.

Laibon's leg was bandaged, but the swelling continued unabated.

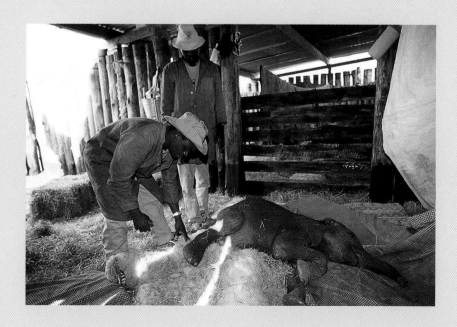

Journey to Freedom
Bound for Tsavo

IN THE COOL TWILIGHT OF DAWN, in the warm glow of lightbulbs that illuminated each stable's interior, trunks were snaking out of every stable door and the babies' anticipation was palpable. The "routine" was changing, and was about to change even more dramatically—the Orphan 8 could sense it. Their move to Tsavo was imminent.

The early years of an elephant's life place it at the heart of its family. The tender, loving care lavished on baby elephants by their mothers and immediate relatives is one of their more endearing qualities. In the first year of life, infants are rarely allowed more than a trunk's length away. Born at roughly 265 pounds (120kg), an infant pours on weight by drinking 10 gallons (24 liters) of milk a day. Elephants are four to five years old before they are weaned. All these factors were incorporated into the formula Daphne developed while raising the orphans and preparing them for the day when they leave the orphanage and begin the journey to freedom.

Ultimately, the move to Tsavo is determined by three criteria: the elies' age, the condition of the vegetation in Tsavo, and how well the elies left behind are expected to fare. After an orphan reaches its first birthday and is doing well, Daphne and Jill decide whether or not it is ready for the long drive to the release site in the red-earth country of Tsavo National Park.

Timing of the trip to Tsavo is also determined by food. Like human babies, elies are milk dependent early in life. Within about nine months, their teeth emerge and they can grind the strips of grass and branches of leaves they have been playfully twisting about with their trunks for the past several months. Around a year old, they begin to incorporate a fair amount of vegetation into their diets, grinding it with their new teeth. Despite the increasing volume of plants being chewed, however, they are still dependent on milk for another two to three years—still, it is this shift toward vegetation in their diet that is needed before the orphans can make the break from the orphanage to the bush.

Rain in Tsavo directly impacts the availability and value of its vegetation. Rains there are not always predictable. While giant thunderstorms roll across the Indian Ocean and soak the coast, just inland and 1,000 meters higher, they can appear, roll overhead, and pass without a drop. The bush can become brittle and seemingly lifeless under the unrelenting heat. For the little elies coming from the relatively temperate climate in the Ngong foothills near Nairobi, the transition

can be too dramatic. An ample supply of vegetation is needed to reduce stress during this critical period—so moves are synchronized to the rains. This year the rains haven't been good, but the Orphan 8 are taxing the capacity of the orphanage, and the staff must make the decision to take them east to Tsavo National Park.

Tsavo is a unique wilderness. The word *tsavo* means red in the local Maasai language. It is a breathtakingly wild and rugged country, steeped in lore and history. In fact, many longtime residents refer to it as the only wild country left in Kenya. It is here that the infamous lions, the "Man Eaters of Tsavo" live—lions of notorious power and aggression. It is here, too, that elephants have roamed and dominated the landscape for centuries. In the 1960s, before the greed of the "Ivory Wars" began the horrendous slaughter of entire families and herds of elephants, herds of more than 100 were commonplace. At one documented gathering, an astonishing 6,000 elephants convened. But then the days of killing started, and David Sheldrick would recover babies wandering motherless in the bush or standing in shock next to the bodies of their mothers, aunts, and sisters. Daphne's skill at raising orphaned elephants was immediately defined and refined. It is therefore somewhat ironic that the landscape that saw the greatest demise of elephants would become the place of hope for so many orphans.

Finally, the impact on the babies left behind is also taken into account. This had considerable influence on the decision to keep the Orphan 8 together on their journey. For little Nyiro, the move was earlier than normal, since he was only nine months old. Generally, a baby as young as Nyiro would not make the move, but Daphne's experience told her that separating him from the Lilliputian herd would be psychologically devastating. At the same time, the two littlest orphans at the facility were kept apart from the Orphan 8, easing their eventual separation. New arrivals at the orphanage have always fared better when they had an established orphan with whom to connect.

The Orphan 8 was preparing to leave as a single group. Never had so many orphans been transferred in a single move, and the logistics were truly elephantine. Preparations actually began a week ahead as the keepers started teaching the babies to load themselves into the trucks without fear of their dark interiors. Everyone from Natumi, just over two years old, to little Nyiro, only

nine months old, practiced daily. Behind the stables, the staff prepared an earthen loading dock and the trucks were backed into place. Their interiors were cleaned and matted with fresh straw, and blankets were hung to give them a homey smell and feel. Each day the elies were rerouted past the open doors of the trucks where their morning milk bottles awaited—it was planned that the milk bottles and a little hunger would help them adapt to the change in routine.

After a few days everyone got the hang of it—everyone except Natumi and Edie. Being the oldest, they were the most wary of breaks in the routine, a trait that will serve them well in future years. Finally, after considerable coaxing, Edie entered. But it wasn't until the day of departure that Natumi decided she'd give it a go. It was as if she knew what was expected all along, and had decided she just didn't need to practice.

The orphans' wonderful days in the Nairobi orphanage were coming to an end. Wandering about in the predawn before departure, I shot photos of the keepers, each waiting inside their stable with "their" elie. They were blowing into the babies' trunks and speaking soft words of reassurance. I tried to memorize the color of the sky, the smell of the scene, the sounds of human and elephant voices dancing in the cool air. I remembered Laibon and Maluti and wished they were there. In some ways, I too felt like I was leaving home, on a new adventure. Everyone was growing up.

IN A BREAK with their normal routine, the elies are delayed from exiting their individual stables the morning of the move to Tsavo National Park. Trunks are wriggling through the open barn doors and the anticipation is palpable. Patrick speaks softly and blows gently into Natumi's trunk, trying to calm her. She knows, perhaps better than the others, that something is about to happen.

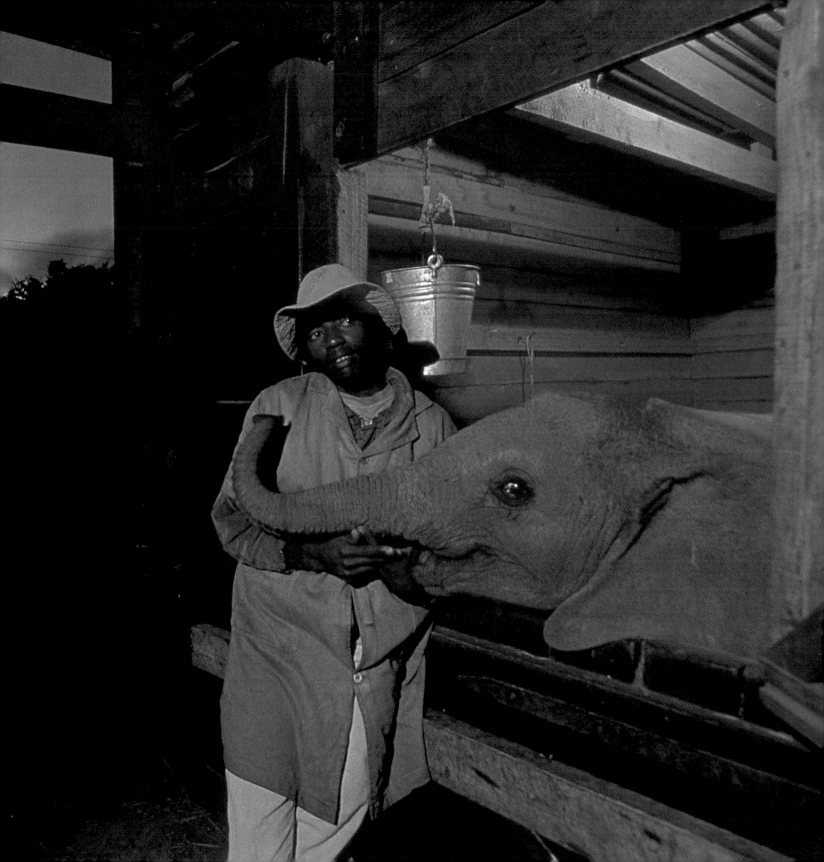

WITH EARS FLARED and trunk curled, little Yatta stands defiantly **(below)** at the entrance to the truck, determined to join the Orphan 8 on their long hot 160-mile journey to freedom in the bush of Tsavo National Park. Their familiarity with the truck and ease with loading makes the morning of the actual move less traumatic on everyone. At more than a year old, Natumi **(bottom)** is already experienced enough to be wary of the truck. Despite being coaxed with the one thing she wants each morning, she stubbornly resists.

The babies of the Orphan 8 flood the truck **(right),** which stands with its doors flung open in welcome. After several days of practice loading, every elie except Natumi (lower right corner), sees the new morning routine as a game, and their eagerness to play sometimes overwhelms the keepers. On moving day, there is ample room for all in the three trucks that carry the Orphan 8 and their keepers.

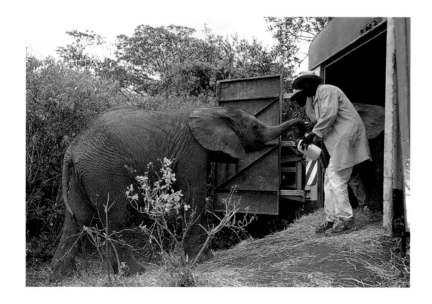

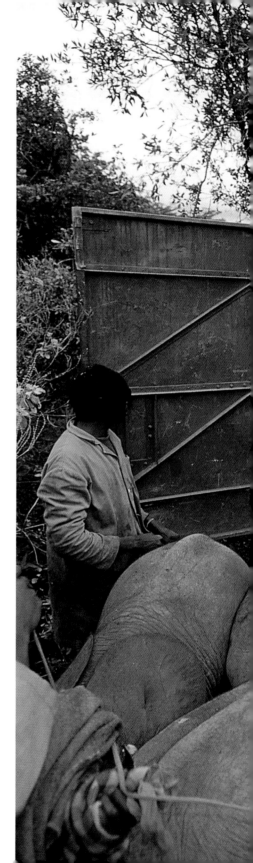

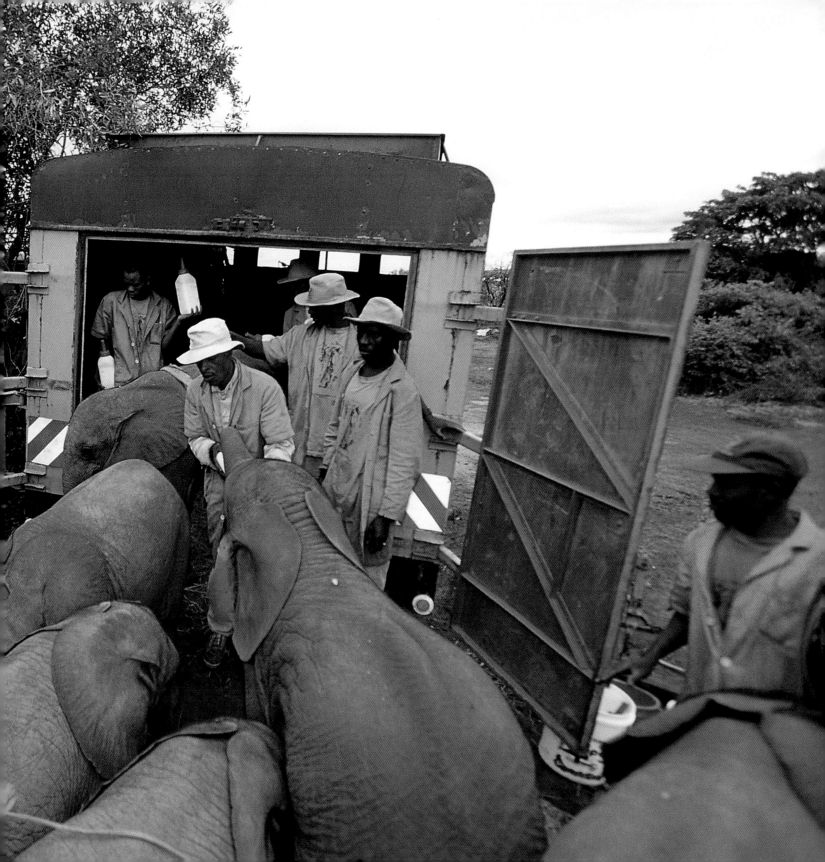

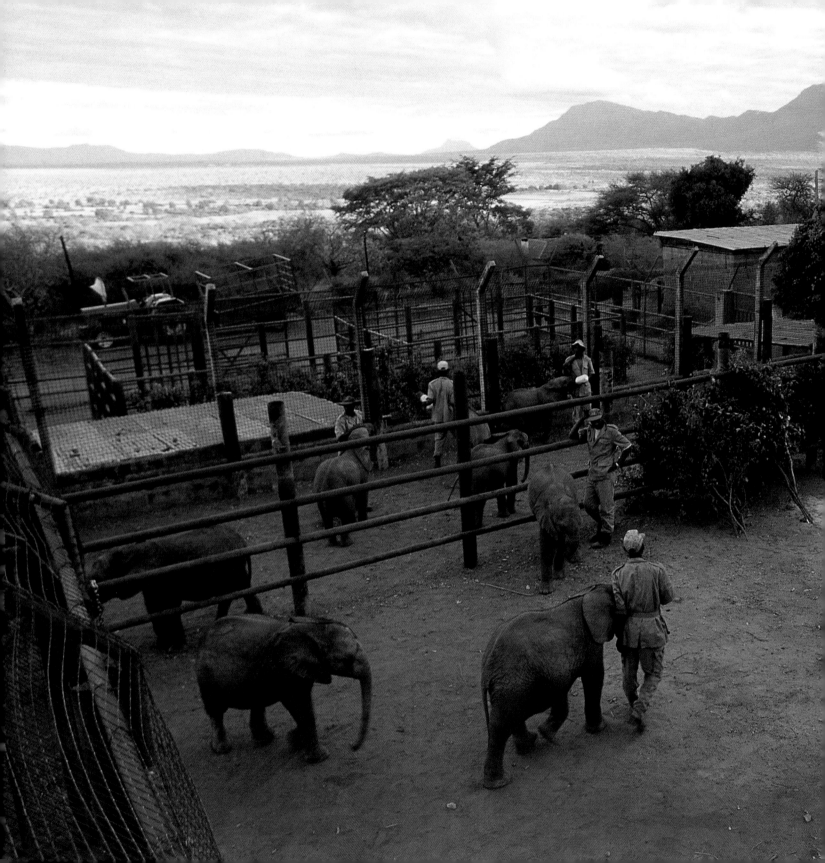

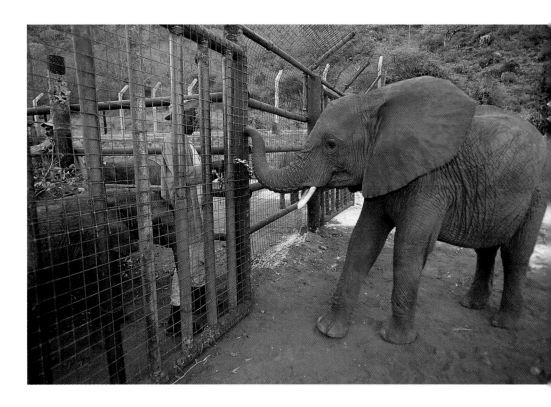

THE VIEW from the Orphan 8's new home **(left)**, the Voi stockade at Tsavo, is wide and breathtaking. Tsavo's raw landscape, home to thousands of wild elephants, offers the orphans an opportunity to hear, see, and smell strangers. Unlike little elies growing up in their natural herd, the Orphan 8 have spent their early life knowing only one another. The ensuing months are full of surprises and alive with opportunities to test their courage and determination. In the early morning hours the day after their arrival, the Orphan 8 are greeted by Malaika **(above)**, an older female, herself orphaned many years earlier and now roaming free in the bush. For the babies, this is an understandably frightening sight—for most it has been months since they have seen an elephant larger than their own "matriarch," Natumi. For others, the memory of giant elephants may never have been firmly planted before they were orphaned. The keepers are cautious about the first encounter between Malaika and the elies, but Malaika is gentle.

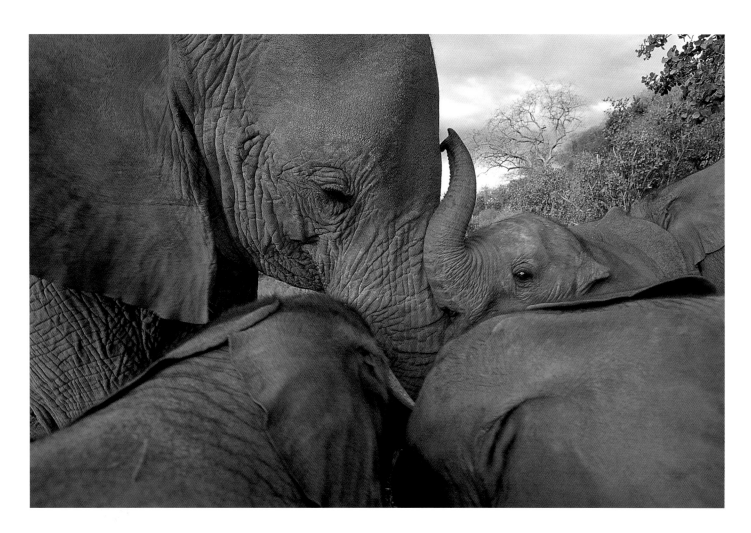

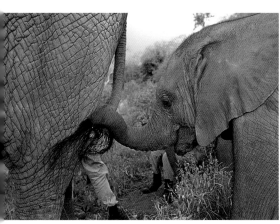

MALAIKA IS EXCITED and eager to adopt the Orphan 8, yet incredibly patient and deliberate in her actions. She seems to completely understand their fears and anxiety over encountering her size. (I fell in love with her immediately.)

During the first days after her arrival in Tsavo, Malaika stands motionless on the fringe of the tiny herd and allows the elies to approach her on their terms. Soon they do.

Malaika begins to wander off **(left)**, and Natumi reaches out and grasps her tail as if to say, "Take me too." For the first time in many months, the responsibility of being the oldest no longer falls on little Natumi.

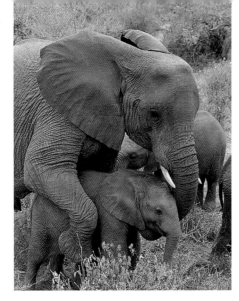

AFTER A FEW DAYS Malaika's need to mother sometimes gets the best of her. Here she positions herself **(left)** behind a baby, expecting it to nuzzle into her breast as a wild elie instinctively does. When her invitation goes unnoticed she swoops the baby up in her gentle trunk and tries squeezing it under her. This is generally followed by the soft squeal of the baby and the intervention of a keeper. Malaika assumes her matriarchal responsibilities with great zeal **(below)**, allowing a baby to eat from "her" bush. Wild mothers teach their calves what plants are valuable as food and as medicines, and in what season they are prime.

Malaika's leadership is proving a valuable asset to the Orphan 8's adjustment to their new world.

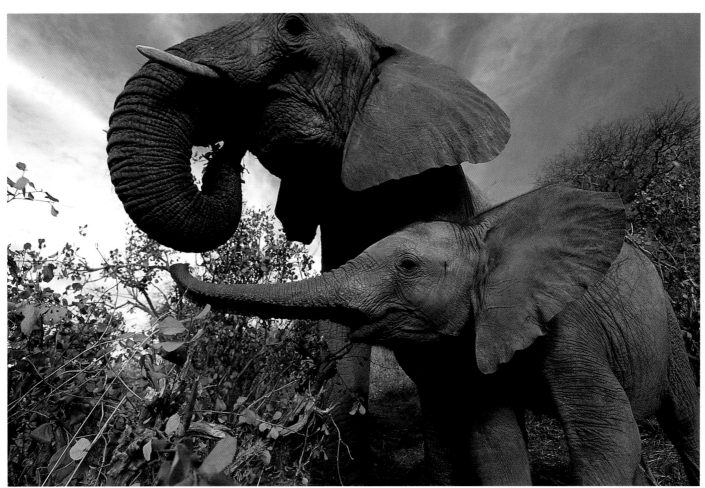

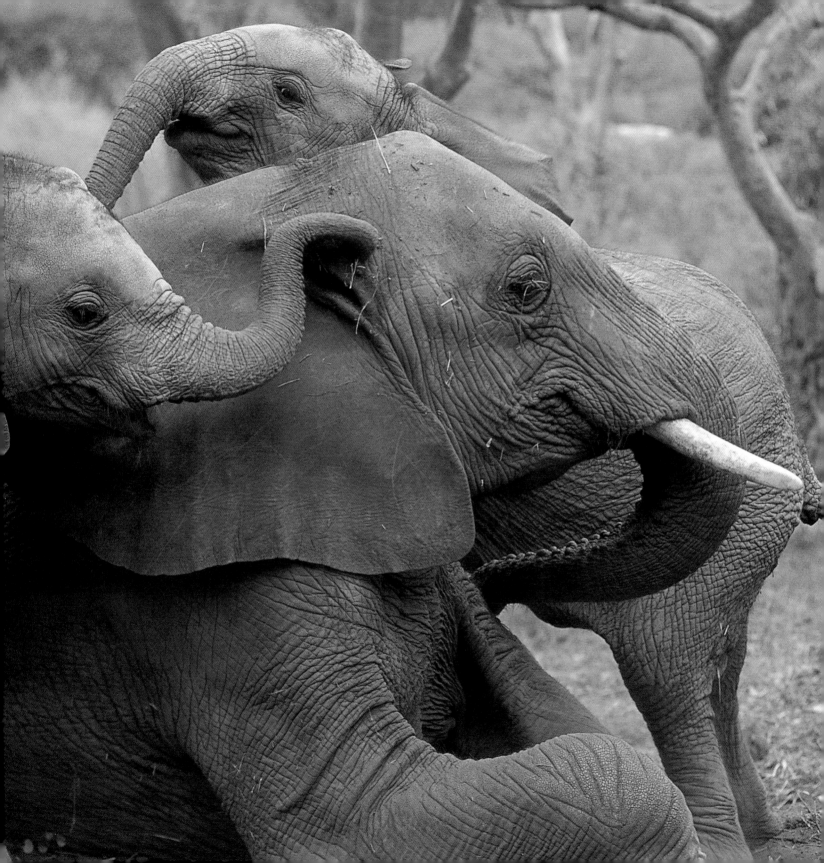

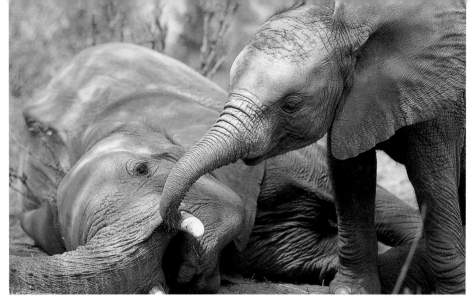

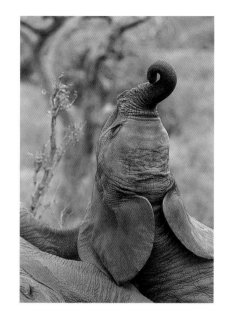

AFTER FIRST CHASING the babies and receiving stern warnings from the keepers, an older orphan, Ementi, gives the babies a chance to come to him, and allows their curiosity to take over. In one of the most extraordinary displays of understanding, acceptance, and gentleness, Ementi, who is desperate to play with the newcomers, lowers himself to the ground and gives himself up to them. For over an hour they roll on him, touch his face, trunk, teeth, and mouth, and treat him as though he is a giant stuffed elephant toy—Ementi is in ecstacy!

Here, during a moment of sheer joy, one of the babies lifts its head skyward and releases a trumpeting blast **(above right)**. In moments of opposite emotion, a baby snuggles into Ementi's "arms" and lies quietly **(below)**, tranquil in the security of its new older brother.

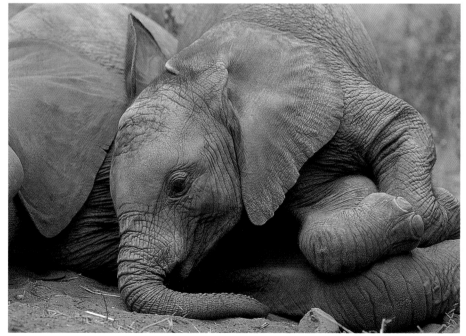

The Elephant Flood Recedes
The Elies Left Behind

AFTER SPENDING a few weeks in Tsavo with the Orphan 8, I returned to the orphanage in Nairobi. Life had quieted dramatically. The elies left behind seemed incredibly small after the "big" orphans in Tsavo. Moreover, after more than a year of more and more orphans flooding through the front gate, everyone needed a rest.

The slower pace allowed me to catch up on other babies: newly arrived elies, a pair of plains zebras, and a lone black rhino baby. The Sheldrick orphanage is famous for its baby elies, but it also has the most successful black rhino orphan-rearing program in the world.

On the day we departed for Tsavo, we left behind three elies too small to make the transition to the harsh wilds. They were now forming their own herd and we could only hope there would be no more. (However, as of this writing in early 2002, the three above are in Tsavo and another seven baby elephants have arrived in Nairobi.)

Because of the great number of baby elephants, extra facilities had been constructed at a high cost—now these stood empty and quiet, as everyone hoped they would remain. But it was at the midday mud bath that the Orphan 8's absence was most glaring. Just a few weeks before, the mud-fest was a chaotic revelry of elies, squirting, rolling, and chasing about. Now it seemed almost too tranquil.

It wasn't until a few days later, when a large group of visitors arrived and shrieked with delight at the baby elies, that I reflected on how excited I was when it had been just Natumi, Edie, and Ilingwezi. It meant so much for the public to see these babies and hear their stories. For many—most important, the local school children—these little orphans were as close to African wildlife as they would ever get. Here were living, rambunctious, trumpeting baby elephants, spraying the terra-cotta mud of Africa all over them—how could life be any more spectacular?

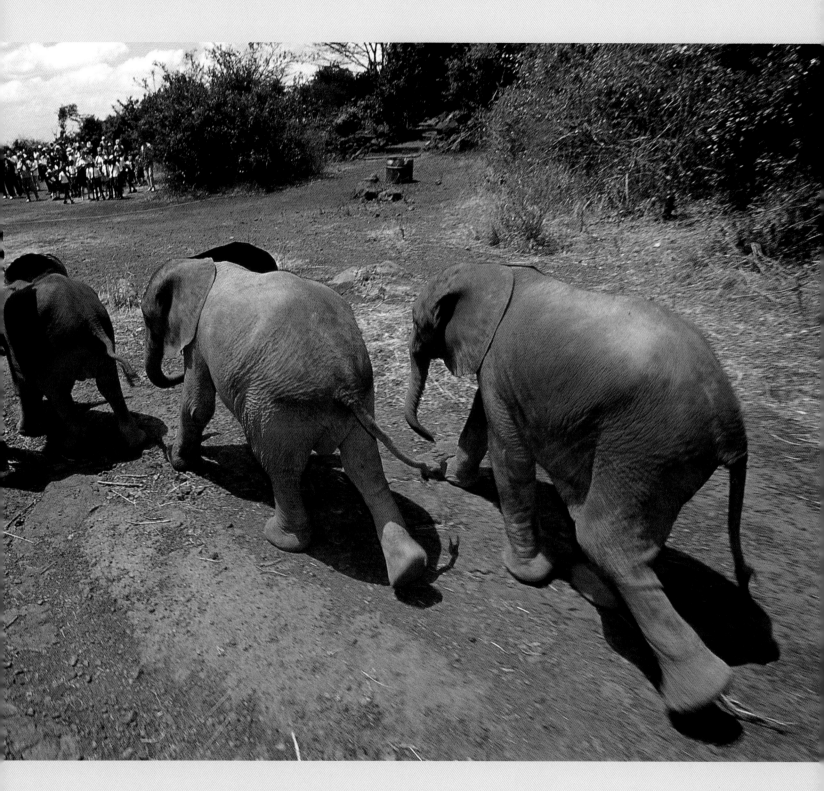

Beyond
Red Clay Days
Lessons Worth
Learning

THE ORPHAN 8 AND THEIR KEEPERS HAD BEEN IN TSAVO NATIONAL PARK for nearly a year before I was able to spend an extended period of time focused solely on them. Since their arrival, other Wild Orphan projects had surfaced which required my attention and kept me from having the extended stay in Tsavo that I desperately wanted. Finally, I got the stretch I longed for.

Upon my arrival, I was immediately struck by the green flush of the red country I thought I knew. All across the landscape, the acacia trees were in bloom and humming with the sound of bees in haste to make what they could of the opportune rains that had sprung this dry world to life. There are two practical access points into the national park. The first is the paved Nairobi-Mombasa Highway through Voi town, which parallels the railroad line coming up from the coast and into Nairobi; it is the historical lifeline that created the capital city. The second road breaks from the highway and splits at an angle through the wilderness toward Voi. It was this dark brick red road, cutting through the lush bush, that I chose as the route for my return.

The moment I began down the track it was clear this was going to be a different visit. I braked around a small bend, easing past two mature bull elephants who stood looming in the road. They were massive, aging giants with huge sweeping tusks, the older of the two having broken his on both sides. These "boys" each exceeded seven tons, and their tusks, while broken from wear, were still impressive arcs of ivory. Elephants of this size are so rare that they are virtually never seen beyond the wilderness of Tsavo. The fact that they still survive here, despite possessing such ivory, gave me enormous hope for the Orphan 8.

Two questions kept dancing through my mind. Since the day Wild Orphans began, it seemed everyone asked the question, "When do you release them?" and often on its heels, "When are they wild?" Answering the second is easier: They have always been wild. But determining when to release them isn't so clear cut, because much of the decision rests not with the keepers or the Trust or Daphne Sheldrick but with the individual orphan. For that answer, it takes an understanding of how youngsters mature in their matriarchal herd.

Over a lifetime of 50–60 years, elephants pass through many changes we typically consider exclusively human. Understanding these from an elephant perspective is critical for each of the elies to have a solid opportunity to return to the wild. For the Orphan 8, the crucial years are right

now. Between birth and puberty, much of the individual and social sculpting occurs. What amazed me was how often the experiences of these elies reflected the lessons of my own youth.

The Orphan 8 had already been in Tsavo nearly a year when I returned, had weathered a substantial dry season, and had continued to put on weight—thanks to their regular milk-bottle feedings several times a day and the keepers' vigilance at providing fresh browse cut from the bush in the distant mountains. On the back slope of the hill behind their night stockade, I caught up with them happily munching their way through a sea of succulent grasses, vines, and shrubs. It was like living in a salad bowl. Everywhere they turned there was something to eat—or put another way, virtually everything they looked at was edible. Most noticeable was how much "my" babies had grown. I had never been away from them long enough to see such a dramatic change. They had put on weight: Natumi, Edie, and Ilingwezi were each a good 200 pounds rounder, plumping out at better than a half ton, and even the youngest—Salama, and little Nyiro—were not so little. In fact, the better part of my first day was spent looking at ears, trunks, and head shapes, then questioningly offering a name to the keepers: "Salama?" They would smile and say "No... it's Nyiro," and so it went. The three oldest girls were clearly identifiable, for they offered the biggest surprise of all—tusks! When I saw Natumi with her thumb-size tusks poking out from her upper jaw, I felt the joy a parent must feel when their child sheds baby teeth for those of adulthood.

Maturing meant more than sprouting tusks. With Malaika gone (see page 120) it was taking a while to sort out a new female leader. In the meantime, much was falling on Mishak and the other keepers. The Orphan 8 were beginning to look very much at home in the wilderness of Tsavo National Park, but what would happen to them in the future was still anyone's guess. There had never been so many babies orphaned at one time before—and since these photos were taken, five elies have already joined the eight at Tsavo and another seven are on the way—and the situation presents many possibilities. It is hoped that instead of wandering off to join wild herds, the females will form a herd of their own under the leadership of one of the older female orphans. The males will most likely venture out to join other bachelors. But with full maturity still 5 to 10 years away, it a decision the elies still have to make for themselves. In the meantime, they were growing up before my eyes.

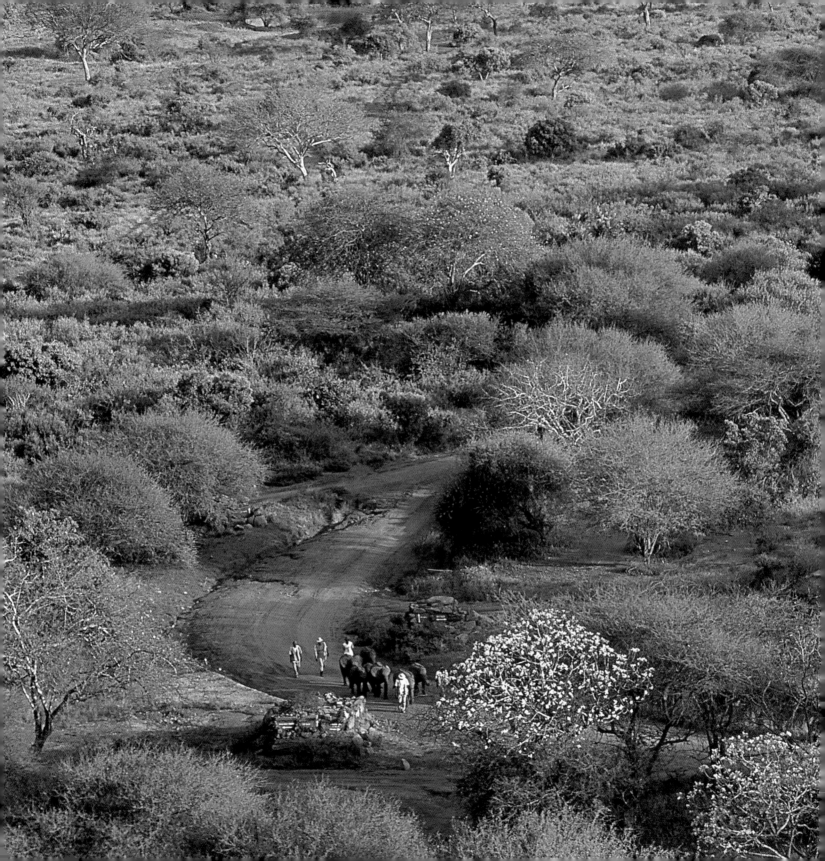

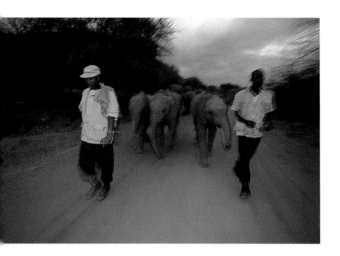

MISHAK LEADS the Orphan 8 out into the cloudy predawn **(above)**. The routine is the same most days, but the elies treat each morning's trip down the park road into the open bush as a moment of celebration. Often they run down the slight incline at full speed—like little kids released from detention. Mishak feeds the Orphan 8 **(right)** their morning ration of copra cake (coconut meal made from the dried meat of the nut, rich in oils) which supplements what they will munch in the bush during the day. Elephants of all ages love the taste of the rich copra cake, but the females are the ones who seem to vie most assertively for it.

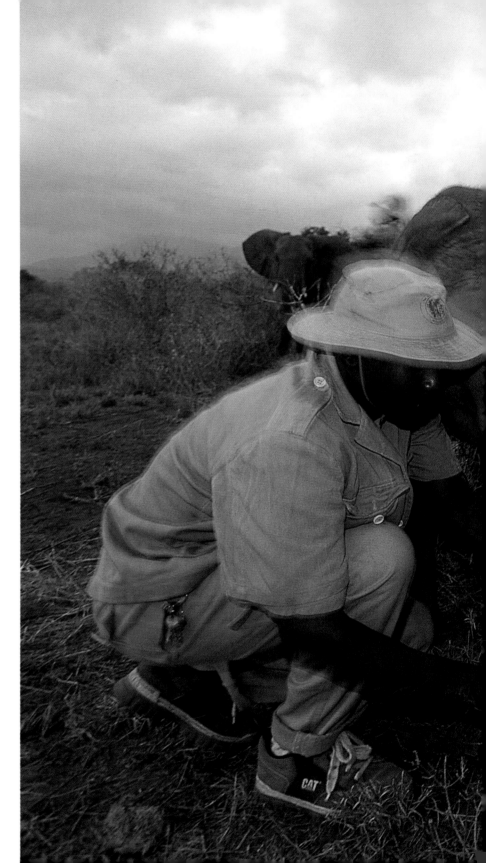

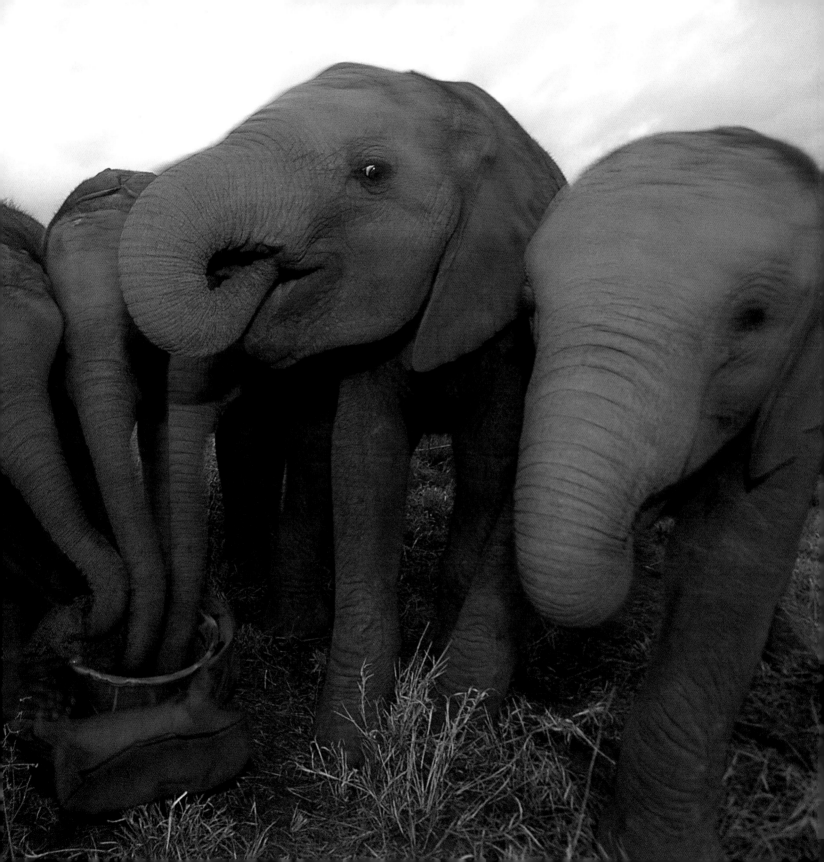

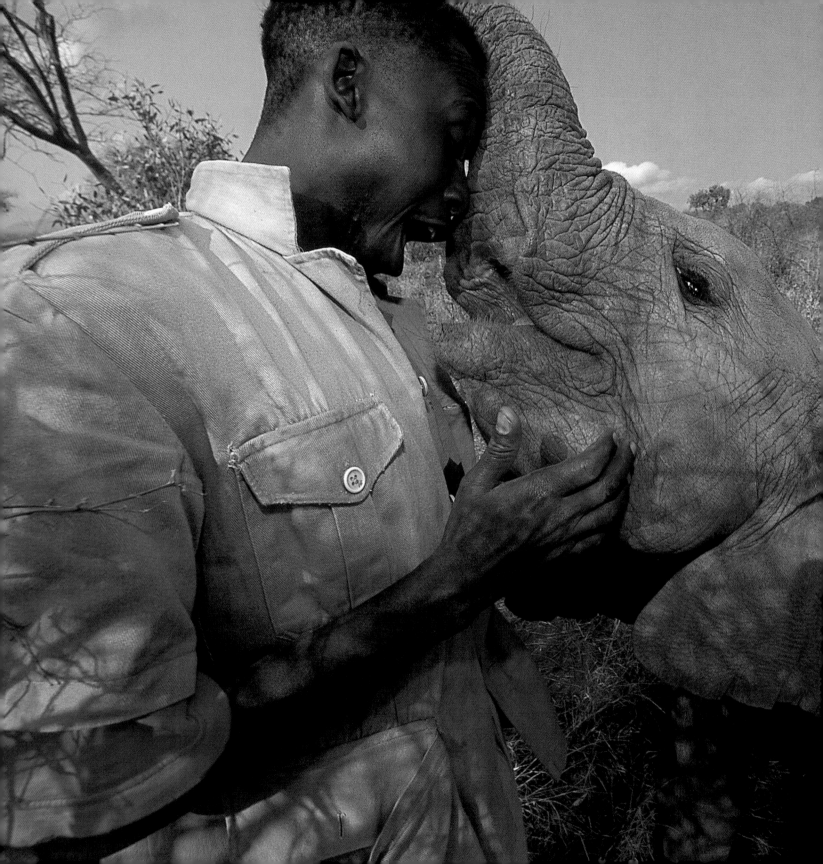

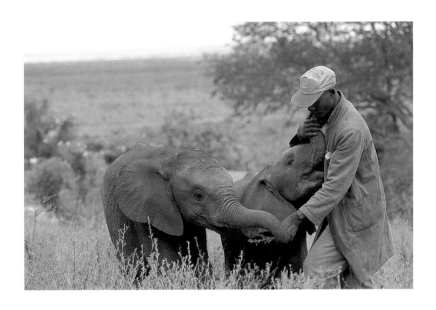

WHO IS THE ENTERTAINER and who is the audience? Benson and Natumi engage in a moment of expression **(left)**. On the outside, this looks like a human playing with an elephant, but with these guys it is a two-way street. Often a baby will spot a keeper with whom they have a special relationship and find a playful way to connect. Mishak does his best to amuse two of the tiniest orphans, Nyiro and Icholta, as they jealously vie for his attention **(above)**. Because they are the smallest and see Mishak as the head of the herd, they often seek his attention while the other orphans are busy elsewhere. In the wild, babies this young would remain very close to their mothers and receive all their attention.

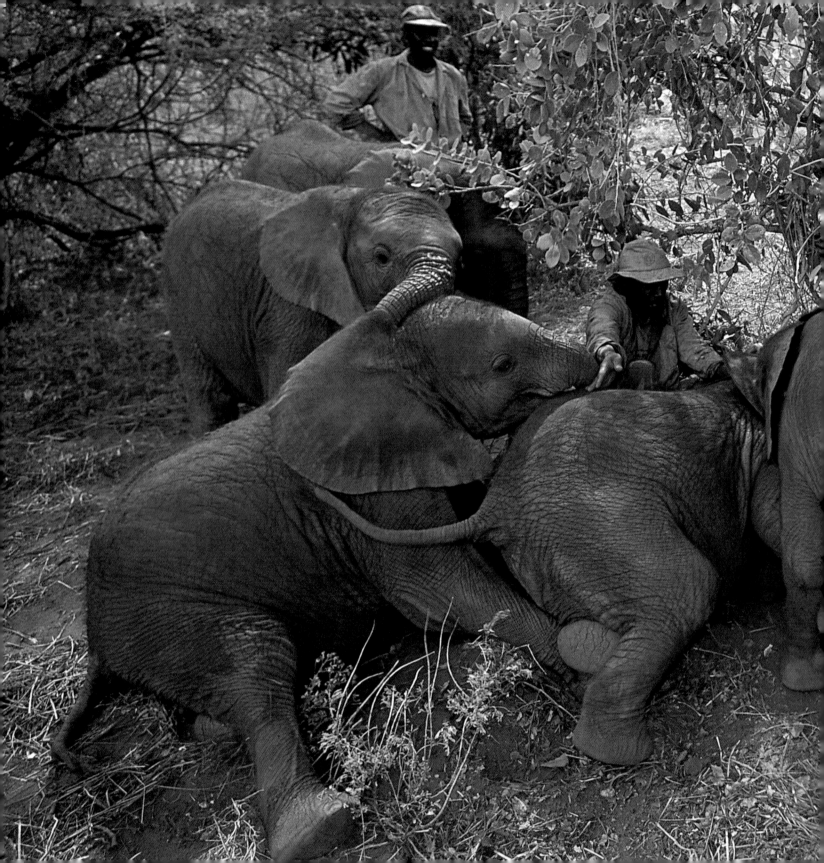

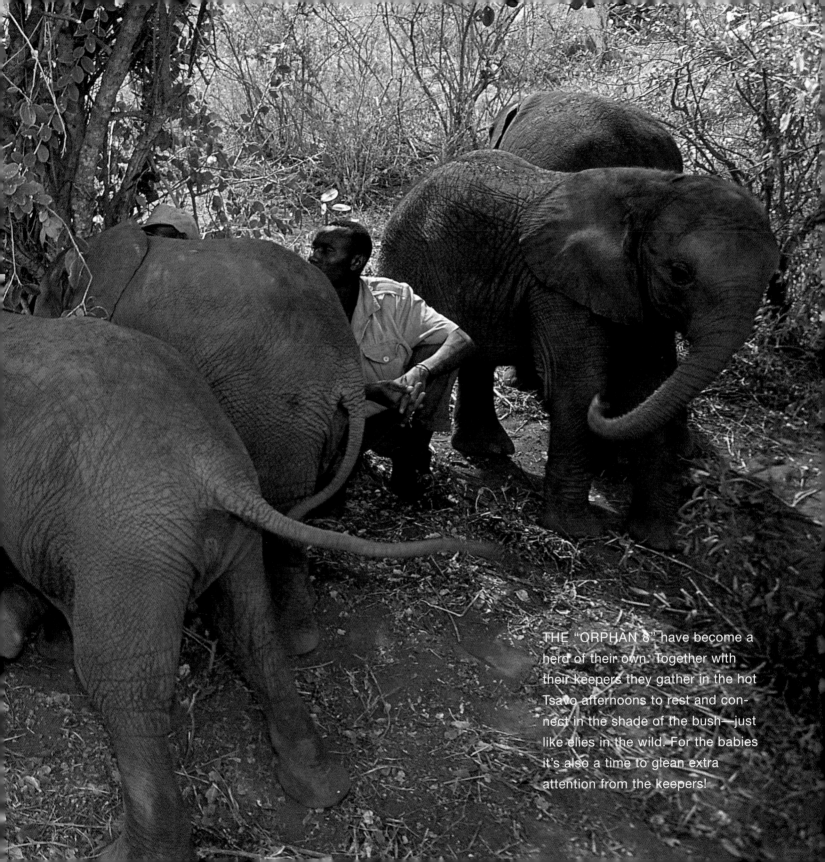

THE "ORPHAN 8" have become a herd of their own. Together with their keepers they gather in the hot Tsavo afternoons to rest and connect in the shade of the bush—just like elies in the wild. For the babies it's also a time to glean extra attention from the keepers!

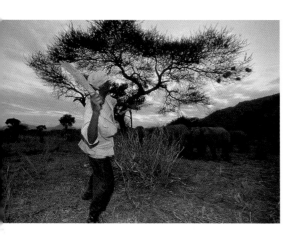

THESE PHOTOS illustrate one of the most extraordinary events I've ever witnessed between humans and wild animals.

The last morning of the last day I spend with the Orphan 8 in Tsavo is gray and cloudy. The older orphans follow us into the bush. All together, we are a herd of nearly 15. The dry season is well under way, and we have to walk farther each day to find roots, stems, and bits of greenery. I am always amazed at what the elies find and at the energy spent in securing the tiniest morsel. One of the richest nutritional treats—as well as the smallest—are the seedpods from the *Acacia tortillis* tree. Ementi discovers a two-story acacia and plucks what he can from the tree. Quickly exhausting the supply within reach, he walks to the trunk of the tree, trumpets a healthy blast, and with his forehead shakes the tree. Down drop scores of pods. Ementi hoards them jealously and refuses to let the little elies share in his windfall.

What follows is another lesson in the Orphan 8's education—and mine. Mishak, ever the "matriarch" of the Orphan 8, calls them over to another acacia nearby. Once they gather, he uses his boot to kick up the little pods lying on the ground, and the elies eagerly vacuum them up. Mishak then begins instructing the babies in the art of acacia seed-pod collecting. This lesson came about as matter-of-factly as if taught by a true matriarch of a herd.

Pointing at the pods hanging in the tree, Mishak throws a **stick into** the branches **(left)**, causing some pods to fall. The Orphan 8 eagerly begin sweeping them up. Mishak shows Natumi and Edie how to uncover them on the ground **(below)**. Finally, in a gesture of generosity, he collects handfuls of pods and offers them to Natumi **(opposite)**.

Afterward, Ilingwezi gets the idea, but not the technique, as she tries pushing on the acacia's trunk. Like the rest, she needs a few more pounds behind her idea. But the lesson has been learned.

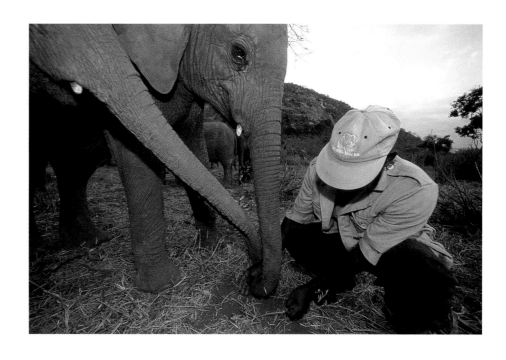

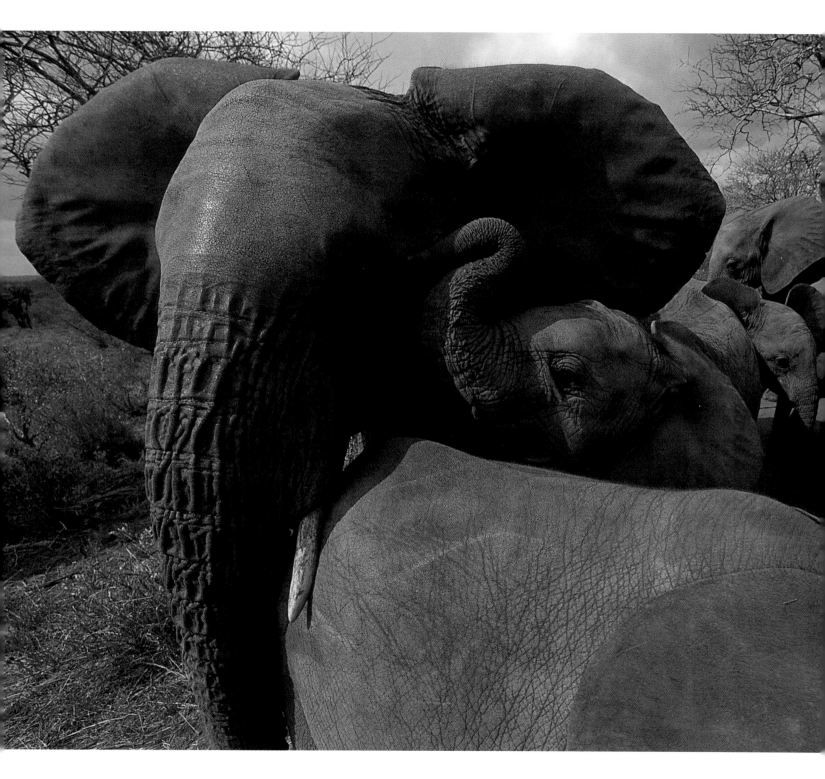

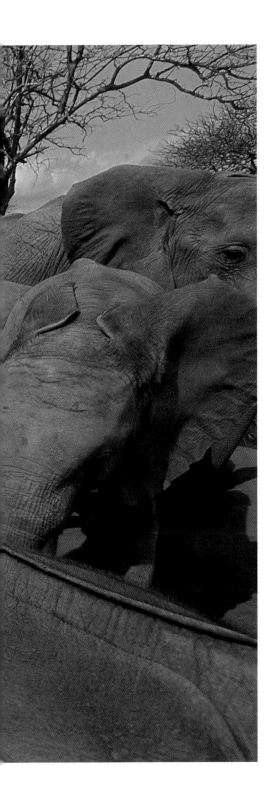

AS THE ORPHAN 8 mature they begin to take on the character of a wild herd. But they are still missing the experience of two or three generations of elders, siblings, and bulls. Fortunately, there are older orphans in their teens and a few who have joined wild herds who occasionally pass by the orphans' territory.

These encounters **(left)** are critical to their coming of age, because, as orphans, the elies miss out on group interaction and the early development of social and language skills.

Elephants communicate with their trunks as fluently as we do with speech. When they meet and greet, trunks immediately take a leading role—feeling their acquaintance's face and ears. People are treated the same way. Every time I return to the elies I get the royal trunk treatment: a wet trunk tip snakes about my upper body, finds my head, and scrutinizes my mouth and jaw, nose, eyes, and ears. Like a topographical handshake, I am remembered, or logged into the memory. Smell and possibly texture may also play a role.

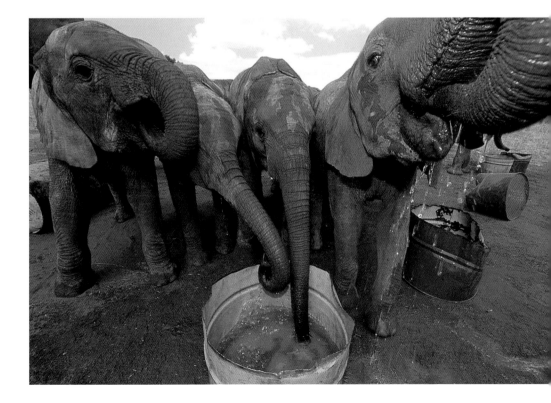

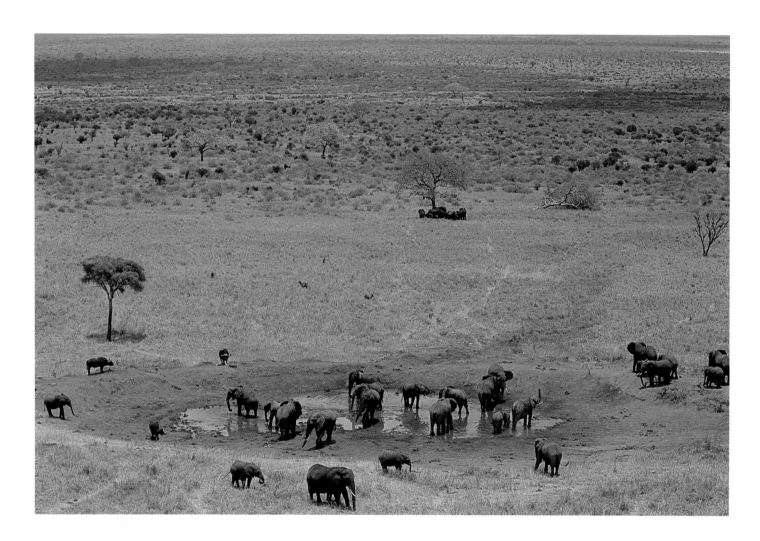

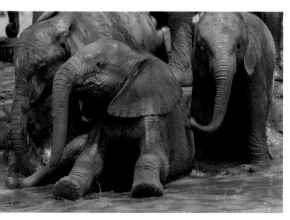

WATERHOLES AND MUD BATHS are socially significant because they provide young wild elies with a chance to encounter other herds and develop social skills **(above)**. Elies frolic in the soupy mud **(left)**, pushing and shoving in play and strengthening social bonds. As they have been since their first days in Nairobi, midday mud baths **(opposite and overleaf)** are joyous and full of energy. Elies love kicking water. (This is a nightmare for the cameras and lenses, yet it provided some of my most entertaining hours in Tsavo).

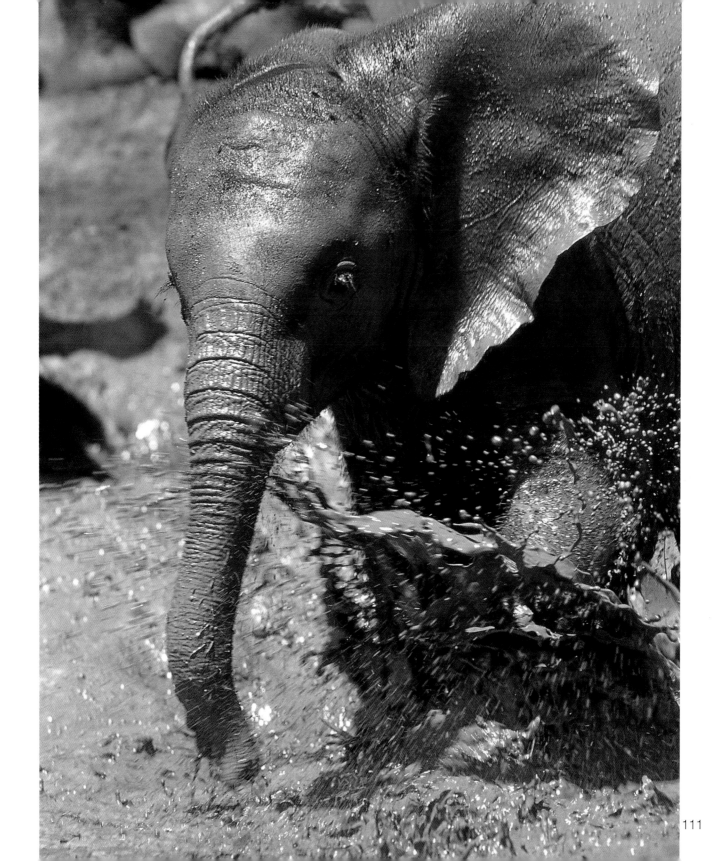

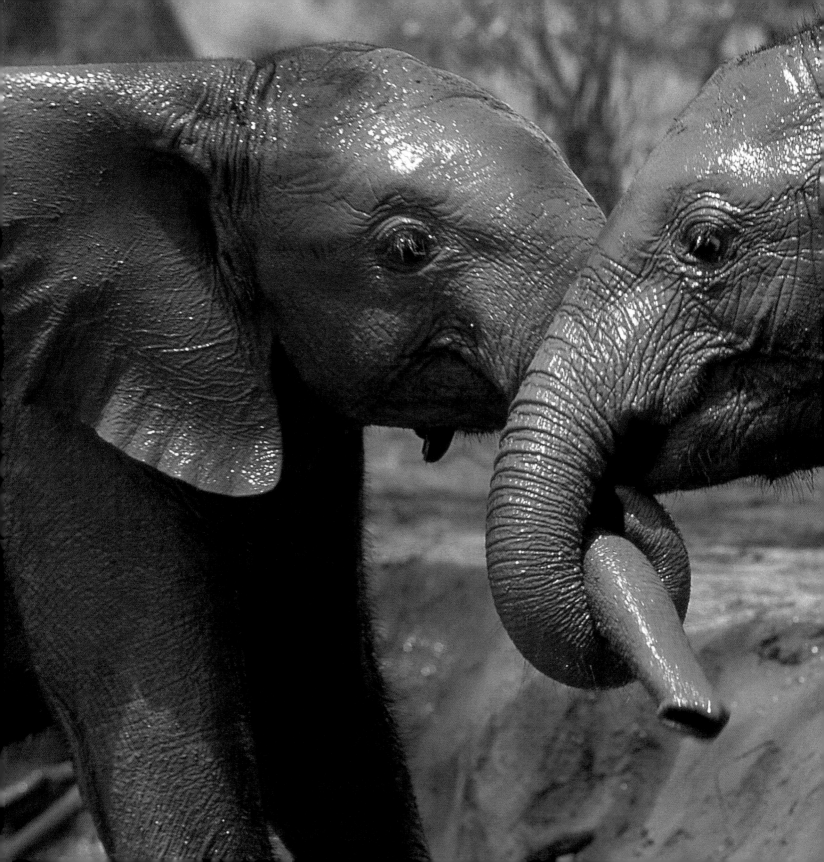

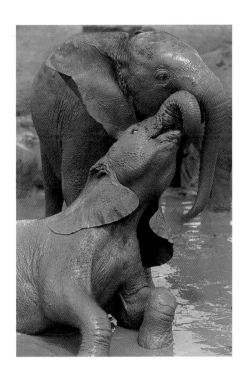

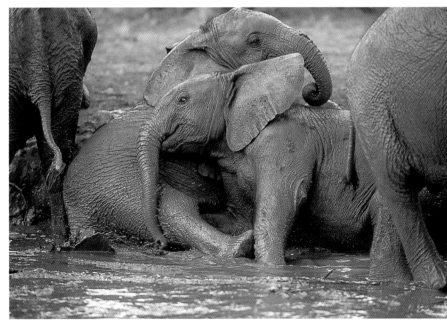

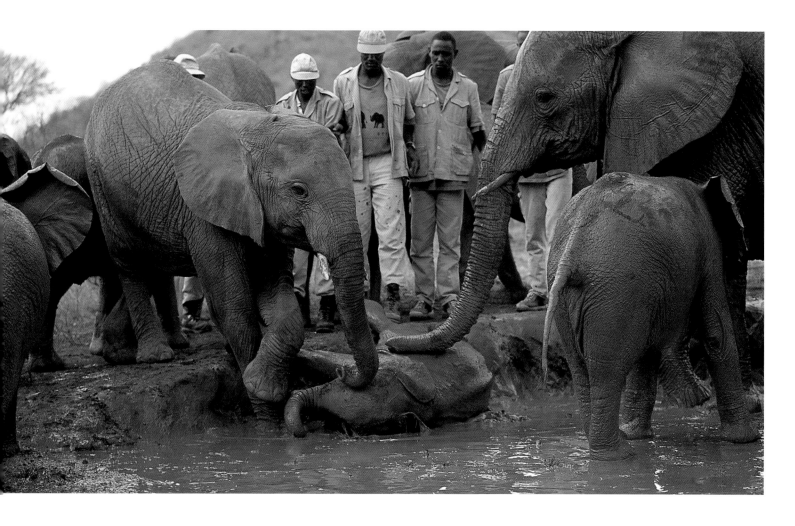

ELEPHANTS ARE FULL of surprises. In the first few months after the Orphan 8 arrive in Tsavo, they settle into their new routine well. Every day is full of great new experiences, and one of their favorites is the midday trip to the mud bath. I also enjoy the Baobab mud bath, as it's called. Open from all sides except one, where a four-story Baobab tree stands overlooking all, it is also intimate, and encourages the elies to play together in a tight group. There is something about wet, gooey mud on a hot day that makes elephants of all ages joyous. It is on such a day that I discover another feature of elephant intelligence: sensitivity and caring.

The Orphan 8 have been at the mud bath for 20 minutes or so before Malaika and her group arrive. On this day, all the elies gather along the north side of the bath, where there is a slick bank with walls a few feet high. As they push and shove one another, the tiniest of the group, Nyiro, flops onto his side and begins wallowing. Suddenly little Nyiro is being knocked about in a forest of giant legs. Perhaps due to a flashback of his recent orphaning, he panicks. Nyiro starts "baby

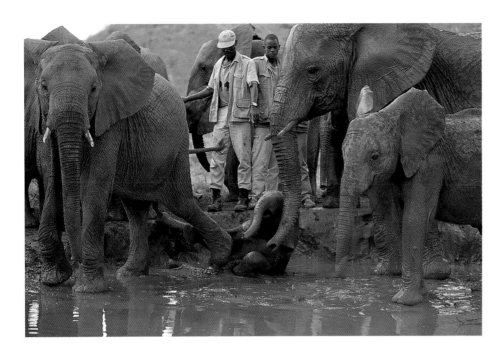

him. Then Aitong joins in by touching Nyiro's head with his trunk. Nyiro begins to rock and finally rolls up onto his knees. Malaika supports Nyiro's head with her trunk **(left)**. Aitong turns and pushes gently with his left foot. After a half minute Nyiro finds himself crawling up the short bank. Salama greets him at the end of his ordeal **(below)**.

Nyiro has done it on his own—almost—and learned a valuable lesson.

screaming," a shrill trumpeting of distress. The other orphans immediately begin showing their distress as well. The older elies, Ementi, Emily, and Aitong, as well as Natumi, move in to help Nyiro, while the other babies circle, confused.

Suddenly Malaika materializes over Nyiro, and with one resonating belly rumble—*bwaaw!*—life comes to a halt. Even the keepers freeze. Then she rumblee again, this time reassuringly. Nyiro lies still. Around him all the elephants stand motionless, trunks hanging straight and silent.

Malaika lays her trunk softly on Nyiro's side **(opposite)** comforting

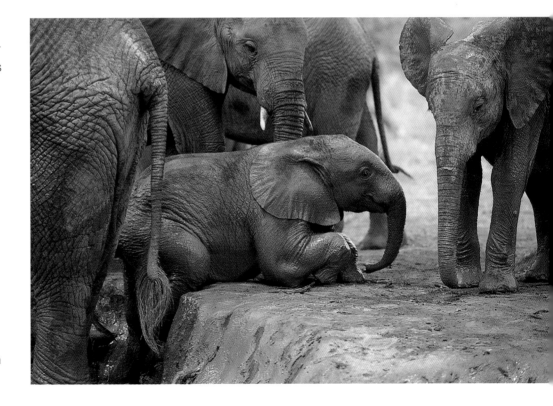

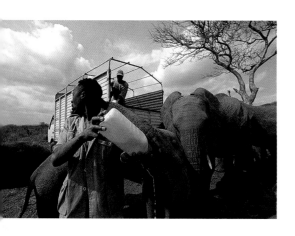

AFTERNOONS SETTLE into a surprisingly monotonous routine. Heat plays a strong role in the "after-mud-bath" lull in activity. Even among wild elephants, the afternoons are very pedestrian. Immediately after the mud bath, a tractor loaded with 1.5-liter milk bottles arrives for the midday feeding **(left)**. With temperatures soaring over 90°F, the need for water is critical. Where wild herds routinely visit swamps or waterholes, the orphans depend on the keepers to shuttle water barrels and buckets. A baby elephant requires 10–15 gallons of water per day.

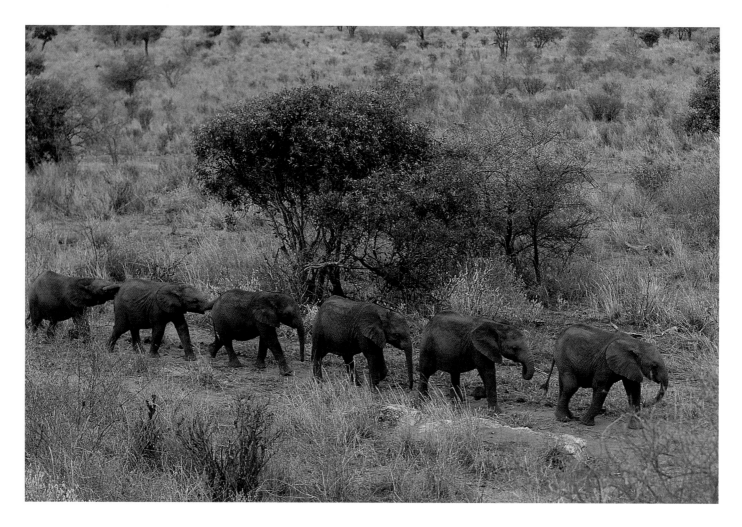

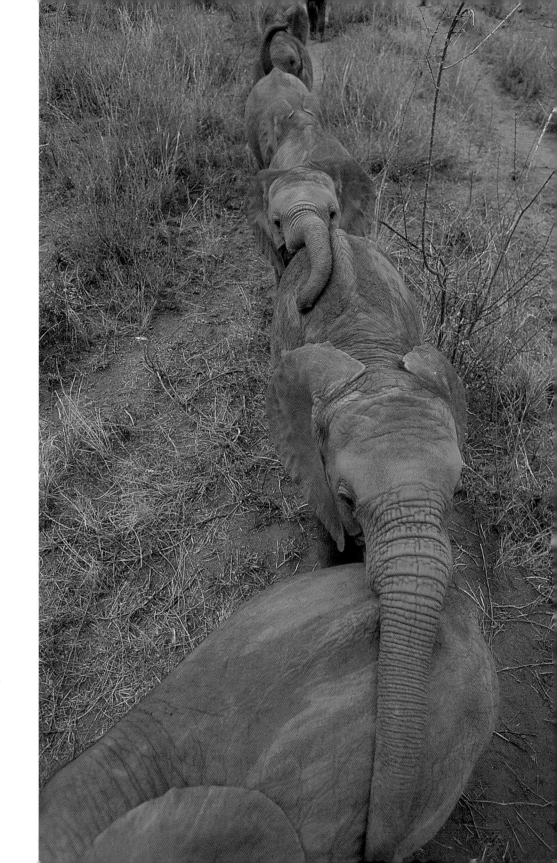

IN THE LATE AFTERNOON,
Natumi leads the orphans back to
the night stockade **(opposite
below and right)**. Maintaining con-
tact in the traveling herd is equal
parts sight, touch, and sound.
When Natumi hears the keepers
(following behind) say "stop," the
scene resembles a train wreck.

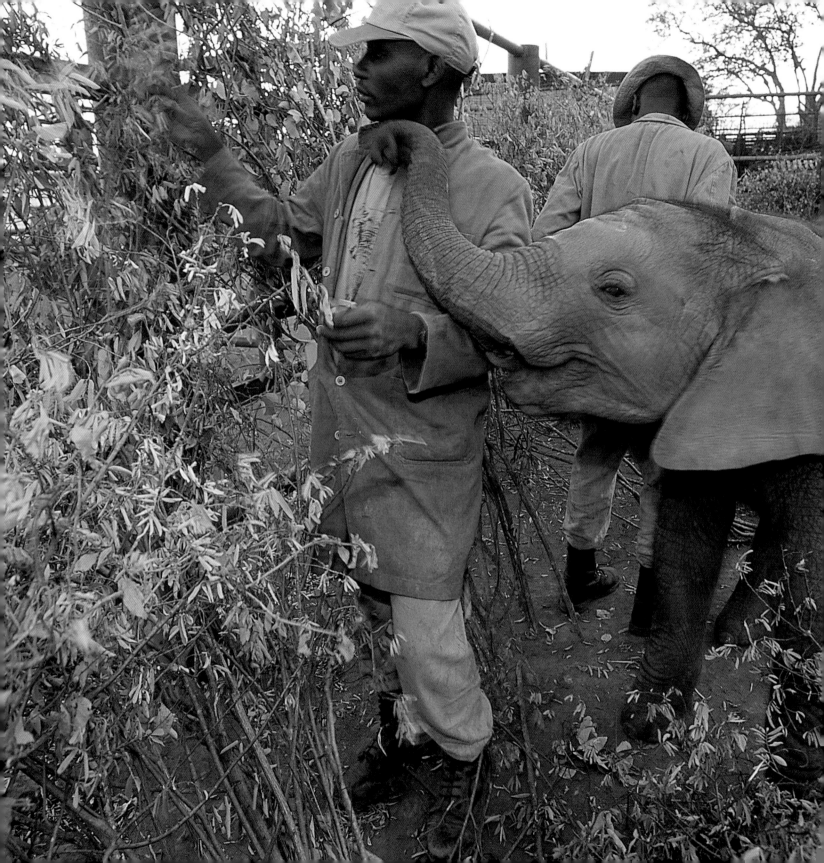

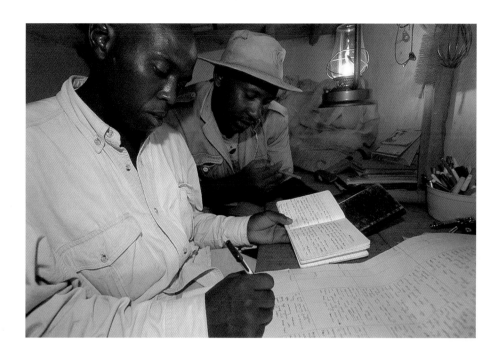

GATHERING IN THE NIGHT stockade at dusk **(left)**, the Orphan 8 find a bounty of fresh food. Here Mishak and Natumi spend a quiet moment connecting and winding down from the day's activities. The night stockade is essential because the babies are still too small, too inexperienced, and too young to defend themselves against lion or leopard attacks.

After a day in the bush, records of events and health are recorded in the "Keeper's Diary" by camp managers Isaac and Mishak **(above)**. These notes are a valuable foundation for caring for the Orphan 8 and those that will surely follow.

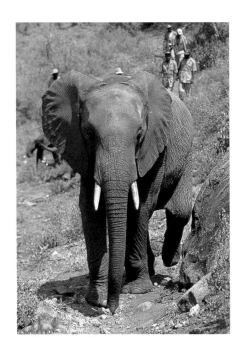

THIS IS AN OBITUARY of sorts, I'll warn you right up front. Malaika died. I'll also admit I'm having a difficult time writing this.

The loss of 12-year-old "wild" orphan Malaika hit everyone very hard. Malaika, whose name means "angel" in Swahili, was a kind and gentle elephant with an amazing capacity to relate to all living things.

Malaika was a young teenage female elephant of genuine size: 9 feet tall and nearly 6,000 pounds. Her dimensions made me look upon her with respect—initially respectful concern. But Malaika was extremely gentle.

From the first morning the Orphan 8 and I met Malaika, she set herself apart. She was a steady, patient guide during the baby orphans' first exposure to the wilds of Tsavo National Park. She extended the same gentleness to this clumsy human. She moved perfectly before the camera. It was clear to me that Malaika would become a major focus of the Wild Orphans project.

Malaika was pregnant when we first met. She appeared at dawn the morning after the babies arrived in Tsavo. She stood patiently outside the night stockade and lazily swished her trunk in the red earth. When the babies were allowed out to meet her they cautiously extended curious trunks to feel and smell the first new elephant they had met since being orphaned. Malaika let the babies gather around her and basked in the joy of the moment.

Over the next few days, Malaika took care to stay with the babies, and seemed to relish the idea of being the matriarch of her own little herd. At times her overwhelming desire to mother would get the best of her as she would try to grab one of the babies and lovingly hold it close. Mishak would occasionally need to remind her they weren't hers with a pointing index finger and a soft, "No Malaika, no."

In August 2000, I left Tsavo with plans of returning to document Malaika giving birth in December or January, but by late September things began to go wrong. The following e-mail arrived from Kenya:

". . .Malaika has come into labor. That was Friday [September 30th] and unfortunately she still hasn't given birth. It seems she has very definite problems and we are at a loss as to what to do. In fact the bottom line is that there is nothing we can do except possibly give her pain-killers and a hormone to induce the baby. This is her fourth day of passing blood and discharge and she is obviously in a huge amount of pain. Not easy to watch but there we are. . . ."

A few days after I received that message, Malaika died. The calf was already dead inside her; it had become lodged in her birth canal.

Perhaps it's fitting that her name means "angel." Angels come from another world. They visit Earth but don't reside here. Angels wing their way delicately, gracefully, between heaven and Earth.

I will miss this beautiful angel— the world is poorer for her passing.

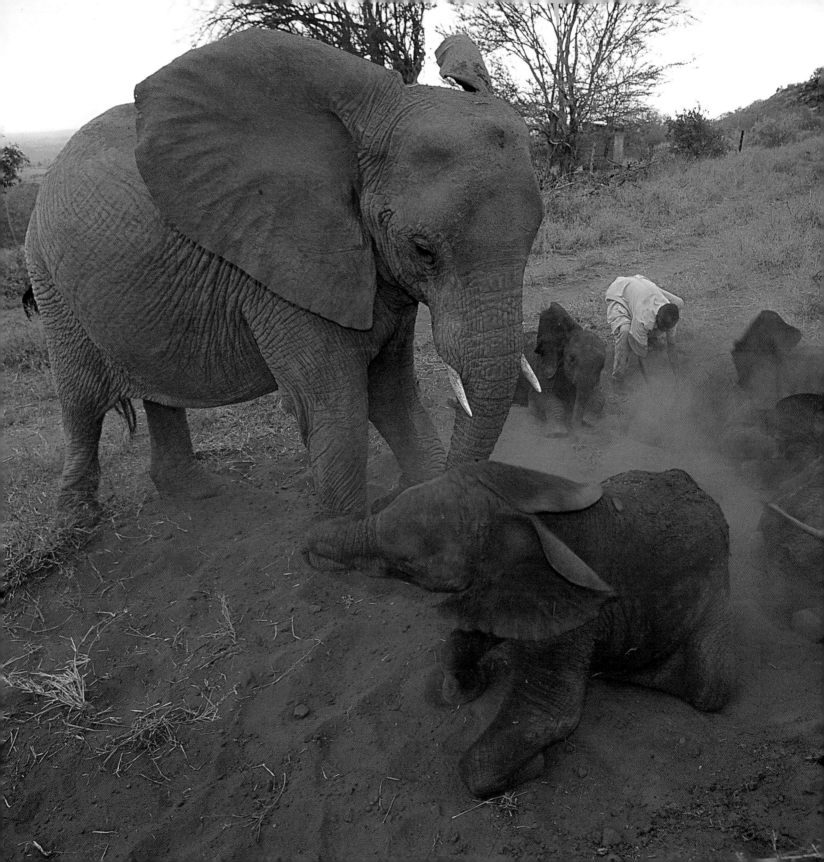

Ivory Ironies:
An Uncertain Future

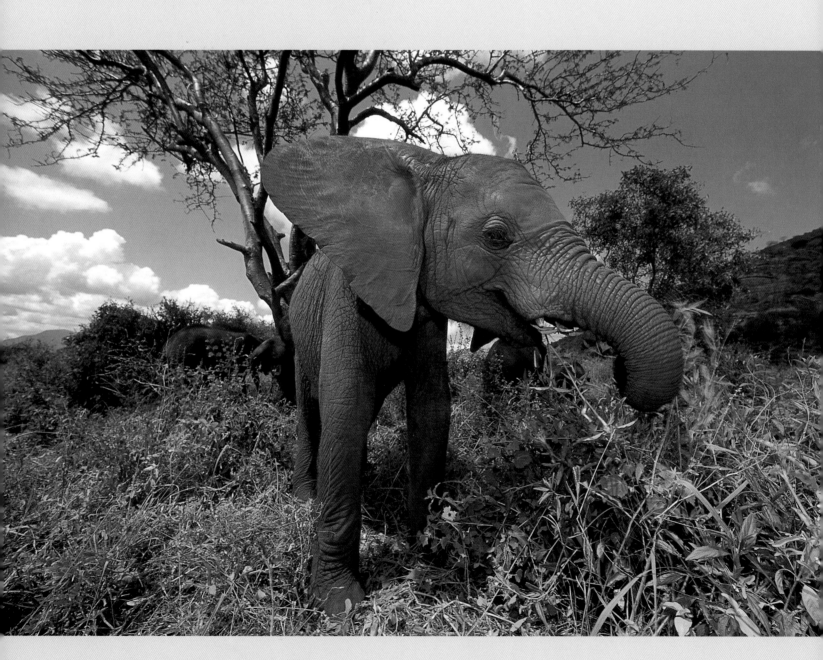

RAISING THESE BABY elies is difficult. But even more difficult may be letting go as we point them towards maturity. Especially because as they face at life in the wilds of Tsavo, their future is uncertain, just as it is for all African elephants.

Of the Orphan 8, I consider Natumi my orphan. She was there the day I arrived in Nairobi. She and I grew up together. Traveling in her shadow over the past few years, I watched her take her first matriarchal steps, lose control to older elephants, and finally settle into a rhythm of youthful maturity—at just four years old. So when I return to Tsavo and see her new tusks, it is a bittersweet moment: My baby is growing up.

Perhaps the greatest irony involved in releasing elephants into Tsavo—or any "protected" area—is the threats they may face there. After all the trials surrounding their rescue and rearing, to give the Orphan 8 back what was taken—their freedom—may mean danger for them once again. These threats can come in innocent forms, such as fences that separate them from crops, or water in a time of drought. Despite their diminished numbers, African elephants are in competition with a swiftly growing number of

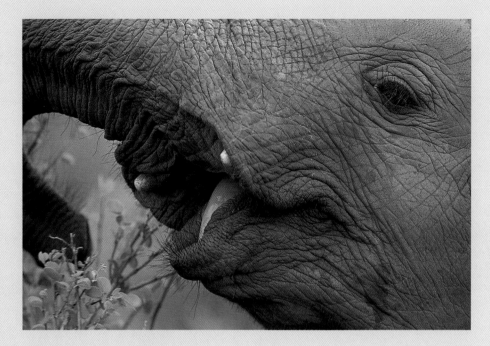

humans for every resource, and space is at a premium.

But it is Natumi's new tusks that worry me most for her future. As she matures and those elegant sweeping tusks grace her profile, their price tag will grow to a bounty of several hundreds or thousands of dollars. Although Tsazo is protected, poaching still goes on within the park. Only the vigilant refusal of people around the world to buy ivory offers her any true security.

Occasionally, the young bulls, Dika and Ndume, reappear after days out wandering in Tsavo. Dika, in particular, loves the babies. As he towers over little Natumi, his youthful tusks are already mas-

sive—the diameter of a tea saucer at their base. Natumi reaches out and feels one with her trunk; she too is impressed. Although not yet 20 years old, Dika's tusks are worth enough on the black market to endanger his life.

The Orphan 8 face a promising future in the relatively safe confines of Tsavo. But many African elephants continue to wander through a dangerous landscape of political instability whose populations could place them in jeopardy by deeming them national nuisances. Once they are gone they will be gone forever and the breathtaking beauty of the African landscape will be lifeless without their graceful shapes.

Elenthropomorphism
The Ties That Bind

I SEE LIFE DIFFERENTLY NOW. Living with eight baby elephants has shined a new light on the world we share. I had intended for *Wild Orphans* to document the environmental pressure humans inflict on wildlife. But the elies led me down a surprising and revealing path. I have photographed chimps, gorillas, and orangutans, and it's easy to see myself reflected in their eyes and expressions, but with African elephants I discovered an extraordinarily different relationship. I did not assume there would be similarities. But little things caught my eye, such as the way they solve intricate dexterity problems with trunk tips instead of fingertips. Learning to understand elephants also taught me how to begin building a bridge between us and the rest of the animal kingdom.

Every day the orphans offered me new learning experiences, many subtle, a few dramatic. I learned more about the infant needs of African elephants than I had ever dreamed—or dreamed they had. Every two hours they needed to be bottle-fed. They had nap times and playtimes, fussy times, happy times, mischievous times, and belligerent times. Had they stood on two feet and spoken to me I wouldn't have thought it so remarkable. But the elephant's distinctly non-Primate design made me reconsider what it means to be human.

The maturation of the African elephant runs parallel to ours. At birth, a newborn wobbles to its feet. It nurses from a mother's teats that are on a breast—the only non-primate to feature such organs. Infancy lasts 12–14 months and then childhood takes over until the early teens (at which time boys and girls begin separate paths toward maturity, males maturing more slowly than females.) As they approach middle age, elephants assume a dominant role in the herd, and according to researchers such as Cynthia Moss, command an "elder" level of respect. Both humans and elephants use their long lives to individually evolve, learn, and pass on knowledge. Both elephant and human females live long after their reproductive cycles cease. Their wisdom is invaluable to the long-term survival of the herd. Nearing their 60s, age takes its graceful toll—jaws and skin wither and hairs turn a silvery-gray. For the elephant who has negotiated life adroitly, the final years can be surrounded by the love and exuberance of youngsters in the family.

When one begins to consider an elephant in such terms, lines between our two species blur, concepts such as anthropomorphism become useless, and we are forced to consider our shared needs; what we both need environmentally for survival.

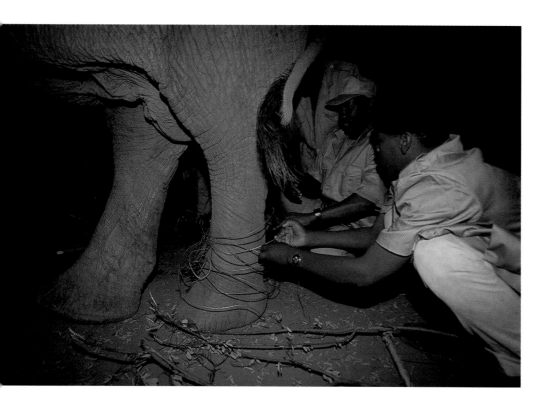

CERTAIN EVENTS resonate with such clarity that the connection between our species and the elephants' is stronger than we think. Pictured here is one of those dramatic events I will never forget. I had only arrived in Tsavo with the Orphan 8 two days earlier. In the dark, I hear the keepers quietly calling "Dika is here!" Once I see his shape I understand their excitement; I immediately slow my approach at seeing something so large. Mishak and Benson do not. They maneuver Dika into the stockade and settle him with fresh boughs of browse. I have never been face to face with an elephant of Dika's size. At only 16 years old, Dika possesses thick robust tusks, a mountainous head, and timber-like legs; he is already massive. What I do not see is the horrible snare wire entangled around his leg. He has obviously walked some distance with it as it has begun cutting into his skin. Steadying him with their gentle, reassuring voices, Mishak and Benson go to work cutting the wire free **(above)**—and Dika never flinches.

Afterward the keepers talk excitedly about the return of Dika and his orphan mate, Ndume. Neither has been back to the stockade in months, having gone into the Tsavo wilds some time ago. The way the keepers explain it, Dika "heard" the babies were here with Mishak and knew Mishak would know how to help him. Dika was one of the first orphans Mishak raised—their bond still remains.

Before Mishak encourages Dika to leave the stockade, he carefully examines him and discovers that a small infection has opened on Dika's temple. Again, with quieting words, Mishak tells Dika to remain still as he begins cleansing the wound and medicating it **(opposite)**. It is seriously infected and it is hard to imagine that the cleaning does not hurt—but Dika endures. Dika and Ndume remain with us for several days, following the Orphan 8 and interacting with them in the most understanding and gentle way.

I have seen Dika numerous times since, and he remains one of the calmest creatures one can imagine—the baby elies love him and seem to relish having his massive hulk nearby.

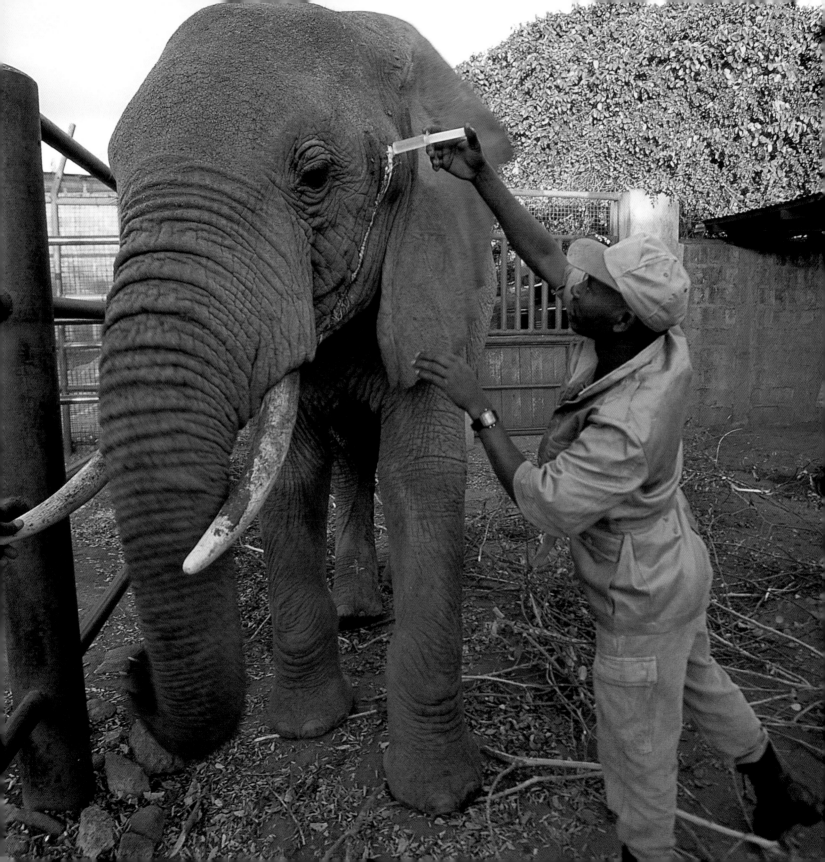

ELEPHANT AFFECTION can often become overwhelming, since the orphans don't always seem to be able to differentiate between themselves and their keepers. As the orphans get older and larger, finding a refuge from their overtures can become a challenge **(below)**.

Understanding the difference between himself and the elies doesn't seem to be a problem for Mishak. Neither does elenthropomorphism and anthropomorphism. "We are the same," he once said to me when I probed about his amaz-ingly intuitive connection.

With a single extended index finger Mishak reprimands Malaika for her overly zealous attention to little Natumi **(opposite)**. The scolding is done with the complete understanding of Malaika's need to love the little ones. "She wants the baby to be hers," Mishak says.

One of the other keepers talks about Malaika's need in terms of his own wife before they had a child. He says she always wanted to hold her sister's baby: "Malaika is the same."

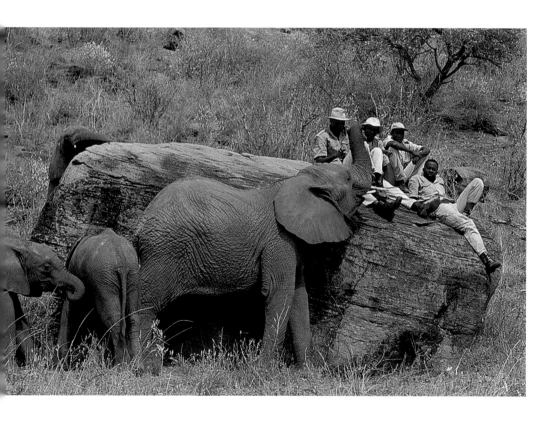

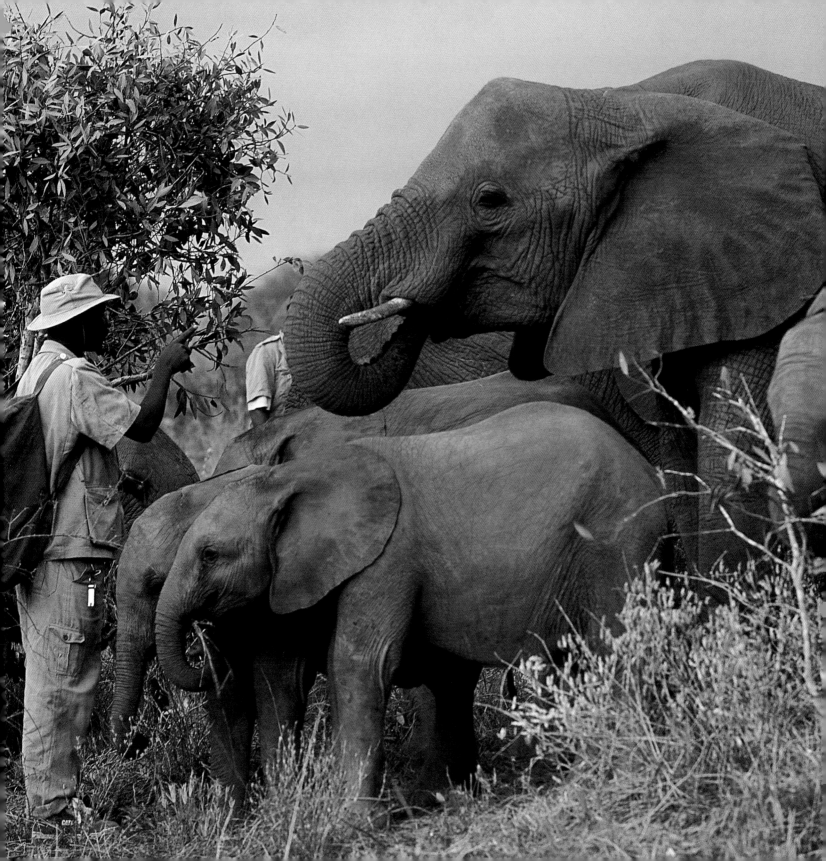

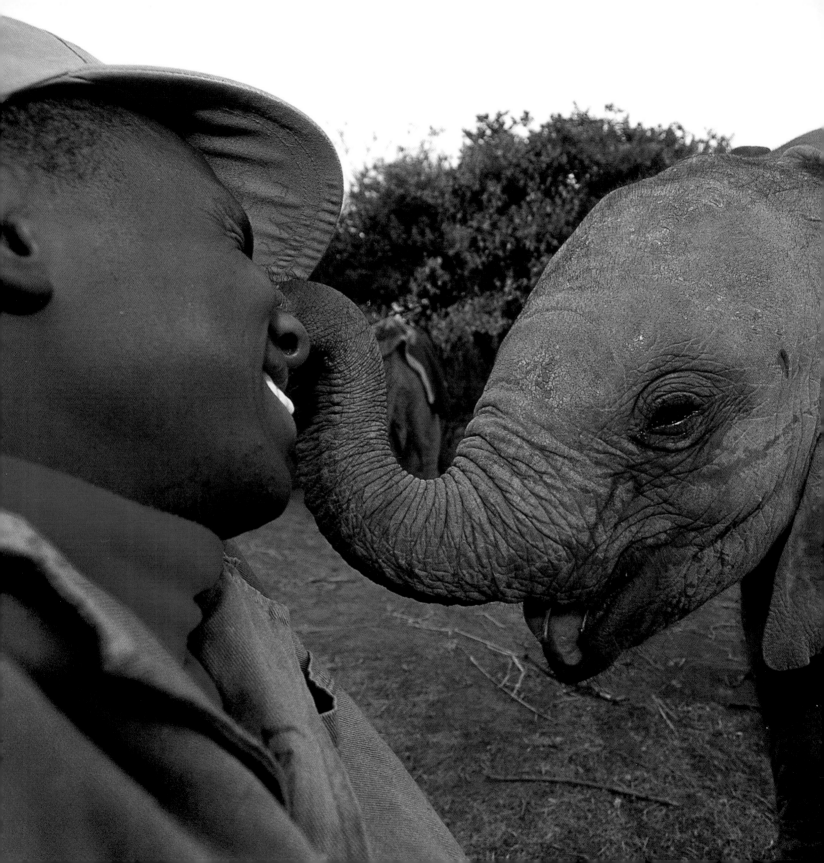

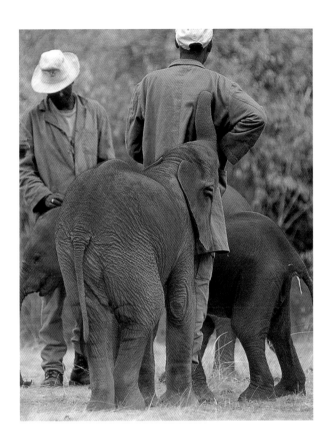

GETTING TO KNOW each other is part of the earliest days in the orphanage. Julius displays the gentle, accepting quality that all great keepers must possess if a baby is going to bond with them and survive.

Kinna, with her burn-sculpted ears, shares a laugh with Julius while "snorkeling" his face **(left)**. Snorkeling is a critical bonding and identification method elephants use throughout their lives. By repeatedly navigating their trunks along the contours of a face—human or elephant—they build a mental map that also includes textural information. Elephants can recognize facial features in other elephants, both living and dead. Coming upon the remains of another elephant, they will focus on the bones of the face and head—if their discovery matches a mental map in their memory, they will linger and explore the bones further.

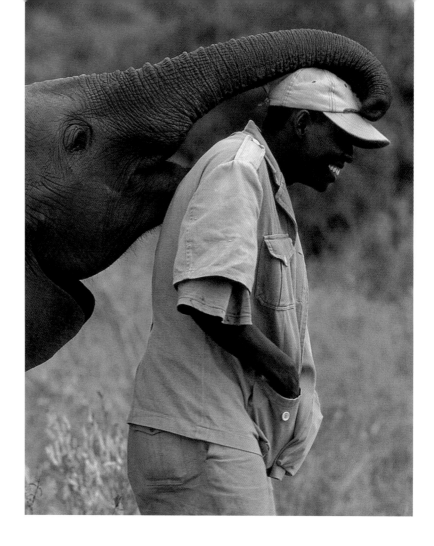

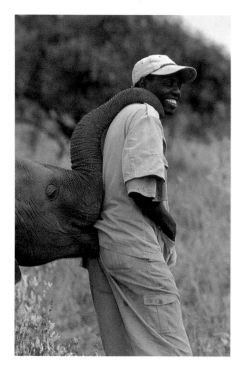

NATUMI "STEALS" Patrick's hat. I'm often asked about photos that seem to show elephants smiling "as if they were human." "No," I reply, "they're smiling like they are elephants." Anyone who stays any time at all with elephants comes to the same conclusion.

"Elephants are self-aware," says researcher Joyce Poole, and I agree. Every time I watch them play a practical joke, I'm struck by their sense of humor—their amusement at their own actions—and their ability to remember a thing they did to you that got a reaction they liked, and then repeat it. So, is that a human or elephant characteristic? The warmth and caring they show one another makes me feel like we're the same. Their ability to learn and decipher things is of constant amazement to me as well, and their awareness of death is now well documented. All this suggests they have a full emotional life. The elephant is much more than the sum of its very large parts.

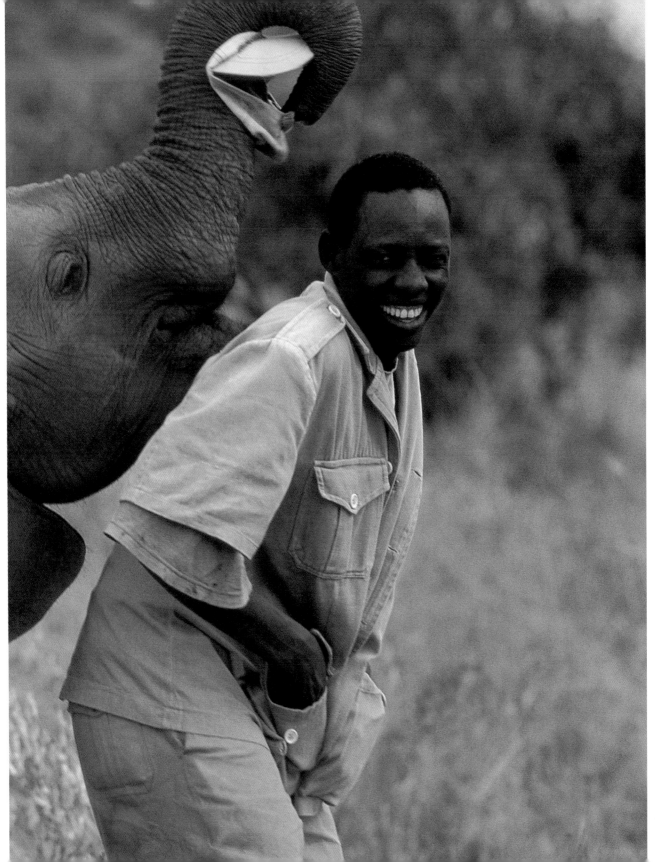

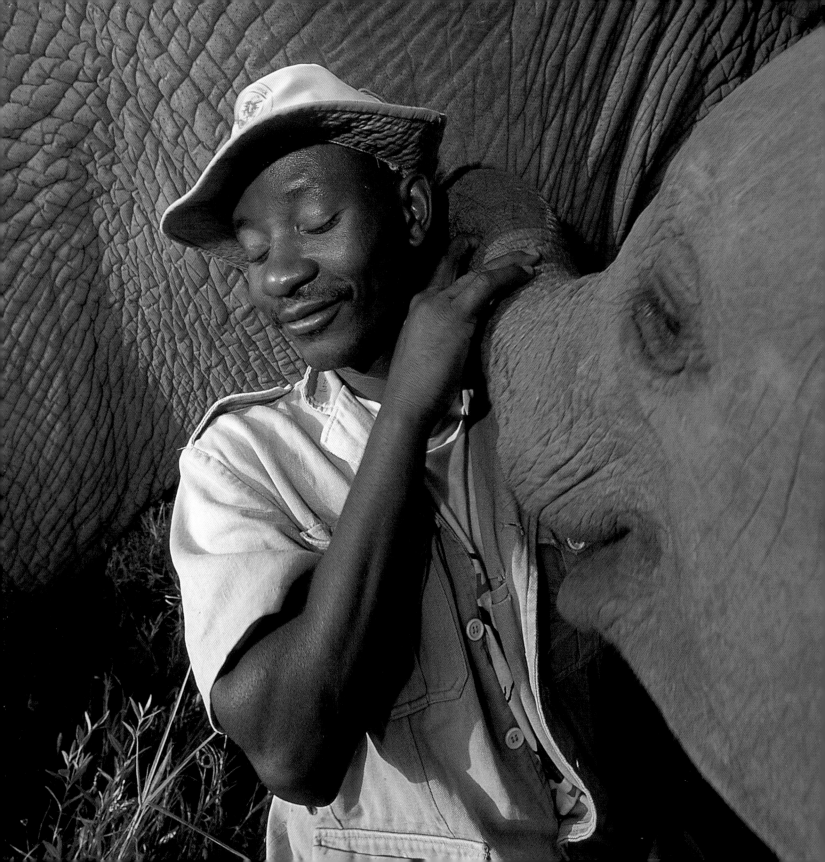

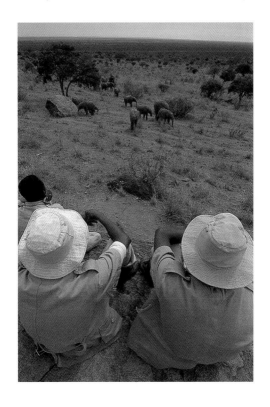

LIKE PEOPLE, elephants live empathetically: The experiences of others become their own, and over that they have no control. Regardless of how an elephant dies—by poaching slaughter, culling, endangerment, or falling down a well—its death inflicts serious psychological damage on other elephants. Considering elephants' ability to communicate over long distances, the tentacles of pain and agony may stretch farther than we know. Culling practices in areas of southern Africa, for example, have been refined over the years so that all the members of a group are killed together. This is done in order to be "kind"—by leaving no survivors behind to be scarred by the event.

I believe that ultimately we will come to understand and save elephants. We will do so because we accept their commonality with us.

"Elenthropomorphic" thinking bridges a vital gap in our reconciliation with nature. It helps to discredit the tightly held belief that aggressive dominance over species—and nature—makes sense. For too long, as author Douglas Chadwick proposes, we have "fashioned a big moral loophole for ourselves so that we can continue to exploit other beings without guilt and confusion." We build physical and moral constructs to distance ourselves: zoos, circuses, virtual video safaris, television channels devoted entirely to "nature," and national parks and reserves. All say "them" and "us."

The concept of saving nature is a profoundly human endeavor. I have never met a wild creature or place which, left on its own, needed me to save it. So, with camera and curiosity, I hope to illuminate what we need to rejoice in and preserve—not what we need to save.

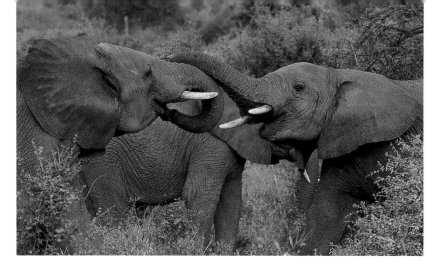

A touching encounter with a wild elephant—a maturing orphan is one step closer to a life in the wild.

GL🜨BIO

THE WILD ORPHANS PROJECT, as documented here, was created to paint a poignant global picture of the impact of human activity on the environment. By focusing on the growing number of orphaned baby wild animals, we hope to create a new awareness about the state of the entire environment. The journey that began four years ago with the "Orphan 8" in Kenya now continues, stronger than ever, as a much larger project, both in the field and on the Internet, as part of GLOBIO—the Foundation for Global Biodiversity Education for Children.

GLOBIO's main field project, Wild Orphans, works intimately with six orphanages on five continents. In each case, the orphanage serves as a living classroom for many local children who might never otherwise experience the magic of their indigenous wildlife, and also as a digital classroom for kids around the world, through our GLOBIOKids website. Moreover, the Wild Orphans project is a way of directly assisting the orphanages with financial, technical, and infrastructural support as they continue to care for dependent orphans.

GLOBIO not only serves as a "voice" for wild orphans throughout the world, but also provides for a better understanding of biodiversity's role and value. We believe there is a missing link between a child's curiosity and the mountains of data we have about life on our planet. We have set out to create a vehicle connecting the two. GLOBIO's mission is to educate children worldwide about the value of the diversity of life on Earth. In doing so, we hope to tap an enormous energy for change. The result will no doubt foster respect for life and increase the value of the magic, awe, and wonder of life around us.

To find out more about orphaned wildlife around the world, join us with a child today at
www.GLOBIO.org